# *Writer of Light*

## *The Cinematography of Vit*

**DATE DUE**

| | | | |
|---|---|---|---|
| OCT 09 2007 | | | |
| | | | |
| | | | |
| | | | |
| | | | |
| | | | |
| | | | |
| | | | |
| | | | |
| | | | |
| | | | |
| | | | |
| | | | |
| | | | |
| | | | |

Demco, Inc. 38-293

# Writer of Light

## The Cinematography of Vittorio Storaro, ASC, AIC

a collection from the pages
of *American Cinematographer* magazine
and the ASC Classic Archives

**Compiled and edited
by *Ray Zone***

Foreword by
Warren Beatty

ASC
PRESS

First Published in 2000

10 9 8 7 6 5 4 3 2 1

Printed in the United States of America

**Library of Congress Cataloguing in Publication Data**
Zone, Ray, ed.
Writer of Light: The Cinematography of Vittorio Storaro
1. Cinematography.    2. Motion Pictures.
ISBN 0-935578-18-8

**ASC Press**
1782 North Orange Drive
Hollywood, California  90028
©2001

**The American Society of Cinematographers**

# *Acknowledgements*

W ith this collection of articles from the pages of *American Cinematographer* magazine and the archives of the American Society of Cinematographers, we examine the films of Vittorio Storaro, ASC, AIC.

This volume is the first in a series of books from the ASC Press on contemporary cinematographers, film formats, genres and classic cameramen from cinema history.

Thanks are due to the authors whose articles are collected here, notably Warren Beatty, Garrett Brown, Bob Fisher, David Heuring and Nora Lee, and to photographers Sidney Baldwin, Peter Sorel, Laurie Sparham, Angelo Novi, Richard Blamshard, A. Bulgari, Basil Pao and Barbara Lakin. Special thanks go to Jerry Ziesmer and Scarecrow Press for permission to include excerpts in this volume.

Acknowledgements are also due to Jim McCullaugh, publisher of *American Cinematographer* magazine, for green-lighting this book, Martha Winterhalter for her excellent art direction and support, Marion Gore for her cover art and book design, and Kathleen Fairweather for assistance with the interviewing, as well as Becca Allen for keeping the ASC Clubhouse open late. And, of course, thanks are due to *il maestro*, Vittorio Storaro, for giving his valuable time for the interviews.

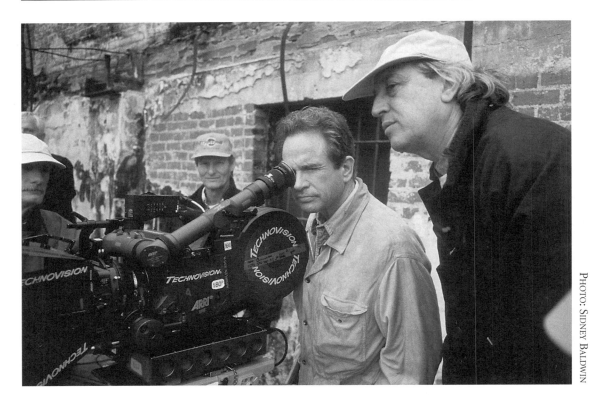

Warren Beatty and Vittorio Storaro during the filming of *Bulworth*.

# *Foreword*

by

## Warren Beatty

There could be no more appropriate recipient of the ASC Lifetime Achievement Award than Vittorio Storaro. He never fails to bring his total artistic integrity to work and helps create such a sensitive, productive atmosphere that it becomes impossible for the rest of us to do anything but respond in kind.

I could make a good case for collaborating with Vittorio even if he suddenly became blind, because I could still count on his mind's eye seeing something inspired and particular while his loyal, adoring crew would do whatever it took to expedite his vision. And still I'd have all the friendship, objectivity, truthfulness and intelligence he brings apart from "writing with light."

When viewing a fresh answer print that Vittorio has delivered, a director is momentarily tempted to release the movie without sound.

I know no one who has advanced cinematography more or contributed more to fellowship among cinematographers. He is so incorruptible, knowledgeable, industrious and painstaking that one anticipates with delight the possibility of catching him in a mistake.

During *Reds, Dick Tracy* and *Bulworth*, I'd look at him and imagine his head to be that of an emperor on an ancient Roman coin.

And why not? His value is inestimable. He is pure gold.

Hail Vittorio!

# Chromatic Narratives

An Introduction

by

## Ray Zone

The world of cinematography has its poet. His name is Vittorio Storaro. After having photographed 40 motion pictures and television productions, Storaro has made an indelible impression upon the art and craft of cinematography. He has given us images and moments that will endure and will be seen as long as people watch movies and TV.

Who could ever forget the stunning imagery of *Apocalypse Now,* with the smoke-filled invasion on the "surfer's" beach or Marlon Brando's face leaning godlike out of surrounding darkness? The luminous splendor of ancient civilizations written upon the screen with *The Last Emperor* and *Little Buddha* inspire us to awe. The photonic blast of sheer color in *Dick Tracy* emblazons our eyes. And the layered images of *One From the Heart* and *Goya in Bourdeaux* invoke a nearly breathless delight.

All of these cinematic pictures, written in light, are the fruit of Storaro's philosophy, his ceaseless wrestling with stories to fashion a chromatic unity out of them. He always finds a key idea, a central concept, around which he unveils a rainbow, a progression of color that will illuminate the narrative and clarify the story to the audience on a level that is immediate and organic. Storaro's images work not only upon our eyes, but on our skin. They will affect our metabolism and, through the power of light and color, play upon our emotions in a way that will surpass our conscious perception and speak directly to the heart and mind.

This mastery of color is the result of hard work and endless research. Storaro is always seeking the meaning of different colors. He plunders art history, ancient cultures, time and space itself to discover the vitality of Red, the maternal warmth of Orange, the consciousness of Yellow, worldly Green, the freedom of Blue, the wisdom

of White. For Storaro, there is a world of symbols and emotion that underlies the spectrum. He will extract the particular meaning of a color or chromatic progression and weld it to different points of a cinematic story. He fashions a voyage through color with every film he makes, and that journey is always a progression of the human soul toward self-discovery.

Storaro is always discovering himself. Every film that he makes is personal to him. By reshaping a script in light, he explains it to himself. Then he is conceptually armed to make light and color reinforce the actions depicted on the screen. He is prepared to create an almost subliminal level of perceptive communication that amplifies and expands the story in a way that is unique. Storaro always speaks of this communication with color and its actions. He is always trying to describe it, and he uses it intuitively on every one of his films.

The preparation, the key or the outline that Storaro creates before lighting a film, is a highly detailed document that he calls his "ideation." The ideation is how Storaro explains the story to himself on a level of color and light and the corresponding symbols and emotions of those colors. The ideation is Storaro's chromatic map of the narrative progression. It is a single-spaced document that, scene-by-scene, outlines a color progression allied to story transitions, narrative events and the emotions of the characters in the script. Storaro always has his ideation with him when he is filming, and it is especially useful, even essential, in postproduction during color correction and timing. Of course, Storaro makes beautiful images with his films. But that is not the point. He is interested in the story that is told on the screen. That is why he refers to himself as a "writer of light." The word "photograph," derived from Greek, means literally "to write with light." But a photograph, Storaro is quick to point out, is but a single, still image. A cinematographer writes with light in space and time. The parameter of movement, the luminous choreography of color in motion, is what interests Storaro. And he is particularly interested in the way in which colors will move and change in concert with unseen emotional and spiritual changes taking place within characters in a story.

With his visible pen and brush of light and color, Storaro writes the symbolic subtext of what is taking place on screen. In a sense, he renders the invisible world of symbol and emotion, idea and memory, into visible form so that we can see it projected in mythic scale before us in the darkened hall.

Great control of light and color is necessary to achieve this form of writing. Using a special lighting system connected to an Iride master dimmer-control board, Storaro can manipulate the lights in real time as the camera is rolling. In his new film *Goya in Bourdeaux*, Storaro's mastery of this unique tool is beautifully apparent. A new palette for Storaro is also available in the TransLite screen that will

receive printed imagery. This translucent scrim will bring images up or down with the dimming up or down of front-and backlight.

With *Goya in Bourdeaux* , Storaro has created a continuous visual metamorphosis using his dimmer control and TransLite screens. The result is a luminous flux of imagery that combines the paintings of Goya with scenes from his life, his loves, and the Spanish court in a manner that is a perfect visual analogue for the actions of memory. *Goya in Bourdeaux* is one continuous dissolve. And the wonder is that it was not achieved with double exposure in postproduction using an optical printer. Storaro is truly writing with light to achieve these chromatic changes in real time as the actors speak and move.

A few years ago, Rosco Cinegel created the "Vittorio Storaro Collection" of colors using the Red-Orange-Yellow-Green-Blue-Indigo-Violet array. These gelatin filters have double density for greater life and more vibrant color. Storaro encouraged Rosco to call these gels the Newton Collection after Isaac Newton, who discovered that white light is composed of a chromatic spectrum running from Red to Violet. Rosco however, chose to name this collection of optical colors after Storaro. They made the right choice.

Storaro reflects on the making of *Apocalypse Now*.

# 1

# Q&A
## with VITTORIO STORARO ASC, AIC

on the filming of

*Apocalypse Now*

Vittorio Storaro, ASC, AIC, had mixed emotions when Francis Ford Coppola contacted him about handling principal cinematography for *Apocalypse Now*.

"I was elated by the possibility of having an opportunity to work with Francis Coppola on this film," he recalls. "However, the work Gordon Willis did with him on *The Godfather* was so exceptional my first thought was that they should be doing this together, too. It was only after Francis convinced me that Willis simply wasn't available for this film that I felt I should do it."

Even then, Storaro admits to having certain concerns. "I knew this would be a very difficult movie to control," he says. "On all of my previous films I was able to create a concept or look by deciding how to control the use of light. However, this film had such an enormous scope I knew control was going to be very difficult to achieve."

As the world now knows, Storaro accepted the challenge and undertook a project requiring principal photography in the Philippines over a 15-month period, from February 1976 through May of the following year. When Storaro stepped up to the podium at the Dorothy Chandler Pavilion to accept the 52nd annual Oscar awarded for cinematography, he thanked Coppola for giving him the freedom to totally express himself during the filming of *Apocalypse Now*.

In those few, simply stated words, Storaro capsulized the creative license Coppola issued to the cinematographer, allowing him to pursue the look which distinguished *Apocalypse Now* in what would have otherwise been very difficult, if not impossible, conditions. "No one anticipated filming *Apocalypse Now* would be such a long and difficult challenge," Storaro says. "We were working a long way from home. Almost all of our scenes were filmed at practical locations, and many of them had enormous scope

in terms of the sheer numbers of people and the size and kinds of landscape involved. The weather was very bad during a long, rainy season. It was a very difficult challenge. Only the vitality and forceful personality of Francis [Coppola] kept us going, trying to retain the level of energy and to keep the look that we established during the first sequences filmed."

We had the opportunity to speak with Storaro only hours before the Academy Awards ceremony. He had flown in from Finland, where he was working on location for Paramount Pictures on the filming of *Reds*. The following are excerpts from our interview:

**American Cinematographer: Tell us something about yourself and how you got started in cinematography?**

**Vittorio Storaro:** I was born in Rome in 1940. My father was a projectionist; however, he had always had his heart set on being a cinematographer. He put his dream into my heart. I attended various schools in Rome, where I studied filmmaking. I soon discovered that making films was a part of my life, a way of expressing my own ideas, my entire being.

**What do you mean, specifically, when you say filmmaking?**

**Storaro:** To me, cinematography means writing with light on film so it creates certain images, moods and feelings when it is projected. There are several styles that have evolved in the culture of filmmaking, which are evident when you study the work of different cinematographers of varying nationalities. I believe my work now is the sum of the culture created by the cinematographers who preceded me. Even the movies that I attended as a youngster while I was studying were a part of my education. What I watched became part of my unconscious memory. What a cinematographer does, then, is take all of that knowledge and add his own personality, or point of view. The quality of the results reflects the sincerity with which a cinematographer handles an assignment.

**Were there specific cinematographers who influenced your work?**

**Storaro:** There were many. Michelangelo Antonioni was one. His films, made mainly during the 1950s, used light in a very realistic way, which had an effect upon the way the stories were told. There are others who used more classical lighting methods. However, I am also influenced by paintings, books, pictures and faces. Just seeing the

way that the light falls on your face while we are talking is knowledge that seeps into my memory to be called upon and used at some future time.

## How did you get started?

**Storaro:** I was working as a camera assistant and operator while I was very young. I started when I was around 20. I very soon had an opportunity to express myself when I shot a black-and-white science-fiction film for a friend. It was my only black-and-white movie, and it was never seen in the United States. But it was my first opportunity to really express myself on film, and like a first love, you never forget it. Franco Rossi, a writer/director in Italy, saw this film, and he was looking for a young cinematographer to shoot *Smog* in 1962. So by the time I was 22 or 23, 1 was already making movies. After that, it wasn't so easy.

## What happened?

**Storaro:** There was a period of around two years when I didn't work. I studied and read, and did some local cinematography in Rome. During this period, I came to realize that I had acquired much technical knowledge like a computer, but I had to start thinking more about how to use it to tell stories. After that period, I started again as an assistant until I got my next opportunity.

## What was that?

**Storaro:** Bernardo Bertolucci telephoned me and asked if I remembered him. We had met on an earlier film. He asked me if I wanted to film *Before the Revolution* for him. That was done in 1965. Later I did several other movies with him that were important to me, including *The Conformist* (1970) and *Last Tango in Paris* (1972).

## Are there films that you have made that are particularly important to you?

**Storaro:** I told you before, the first movie is like the first love. I remember crying two days before we finished production because I was thinking I would never have these experiences again. I might do films that are 100,000 times bigger and better, but this will always be the first time. However, in general, the most important film to me is always the one that I am working on. If you don't have that attitude about life, you miss opportunities to really appreciate what is happening around you. To do anything right, it must have your full concentration. I had just completed shooting *1900* when Francis

contacted me about *Apocalypse Now*. Once I accepted that assignment, that became my most important film until it was completed.

**Did Coppola ever tell you why he wanted you to shoot *Apocalypse Now*?**

**Storaro:** The first time I met him was when he visited the set of *Last Tango in Paris*. He was there to visit with Bertolucci. We just said hello. Later, we met a second time while he was doing a film in Rome. We spoke for about two to three hours. I was surprised at how easily we communicated, even with my poor English. I felt very close to him, like a brother, in a very short time. Later, when he wanted me to do *Apocalypse Now*, he told me that he got the idea of asking me because he admired the work that I had done on *The Conformist*. When we talked, he made me feel that he respected my judgment, and he would give me the freedom to express myself. That is why I decided to accept the assignment.

**Do you consider that you have a certain style of cinematography?**

**Storaro:** To me, making a film is like resolving conflicts between light and dark, cold and warmth, blue and orange or other contrasting colors. There should be a sense of energy, or change or movement, a sense that time is going on. Light becomes night, which reverts to morning; life becomes death. Making a film is like documenting a journey and using light in the style that best suits that particular picture … the concept behind it.

**What was the concept or the look that you were trying to achieve with *Apocalypse Now*?**

**Storaro:** The original idea was to document the impact of superimposing one culture on another. I was trying to show the conflict between technical and natural energy, for example — the dark, shadowy jungle, where natural energy reigns, compared to the American military base, where big, powerful generators and huge, probing lights provided the energy. There was a conflict between technology and nature, as well as between different cultures. I tried to use the lights and camera to suggest this. Remember the USO show with the Playboy bunnies on that huge stage? We framed them in those big spotlights in a way that conflicted with what the eye expected to see against the background of the jungle. It wasn't glaring. It was just a suggestion, something that slightly disturbed the eye. Mainly we tried to use color and light to create the mood of conflict in subtle ways. The way that a red fire in a camp contrasted to a blue or black gun in the foreground, or the way that the color of a weapon stood against a

sunset, or how an American soldier with a blackened face was seen against the green jungle or blue sky … that all helped to create the mood and tell the story.

**From your perspective, what were some of the difficulties in shooting *Apocalypse Now*?**

**Storaro:** Technically, the most difficult period occurred during the rainy season, which lasted from August through December. It was especially difficult at night. We had to handle and protect cameras, lenses, dollies and lights as best we could. Then, on the nights when the rain didn't come, we had to create it and perfectly match the artificial rain to the sequence where it was real. There were no secrets for doing this that I could share. It was very difficult work.

**You qualified that answer by saying "technically." What were some of the human difficulties of working on a big picture like this for so long a period of time?**

**Storaro:** We were working a long way from home. Almost all of our scenes were filmed at practical locations, and many of them had enormous scope in terms of the sheer numbers of people and the size and kinds of landscape involved. I don't believe anyone anticipated that it would be that long and difficult. The first sequence we filmed was the Americans' counter-attack on a native village. It was a very powerful sequence. Once we achieved that, there was no going back. We kept working harder to retain that level. The look of *Apocalypse Now* evolved day by day. We tried to use the changing light and seasons to our advantage to establish the flow of time.

**You mentioned the use of light and color. How about the darkness you employed in scenes involving Marlon Brando?**

**Storaro:** The role that Brando plays represents the dark side of civilization, the subconscious, or the truth that comes out of the darkness. He couldn't be like us, sitting here and talking. It couldn't be normal. He had to be like an idol. Black is like a magic color; you can reveal patterns and moods against a dark scene that aren't possible in other ways. When I saw this scene in my head before we shot it, I pictured it in black, with Brando always in the shadows or the dark side. Coppola gave me the freedom to express this idea.

**In shooting scenes like that, was there any concern on your part about being so far away from the laboratory handling the work?**

**Storaro:** You are always concerned with this. It is human nature. The film (Eastman color negative film 5247) is very good. It has the latitude to show the contrasts between the whites and blacks. I believe that it is even more sensitive than Kodak says. I think the film registers the love and emotions that the cast and crew put into making it. This is very difficult to explain, but I believe that the film accurately recorded the emotions that we were pouring into production every day, scene by scene. We were changing and learning as we produced this film, and all of that energy is captured and shown on the screen. That's part of the emotion that captivates audiences. It isn't a conscious thing , like lighting or framing a certain way to achieve a certain effect. It's the energy that you put into the movie being registered on the film. However, it was also very important for me to know that the laboratory knew what we were trying to achieve. The work was done by Technicolor in Rome. It gave me a great deal of confidence to know that Ernesto Rinaldi, a color timer who has worked with me from the beginning, was there. We usually didn't see dailies until a week later. But Ernesto knows how I think and see things, and he brought our ideas to their final conclusion. Obviously, the lab is very important. It is the final step.

**What about the equipment used for filming *Apocalypse Now*?**

**Storaro:** Technovision, an Italian company, modified Mitchell reflex cameras to use Cooke anamorphic lenses made in England for this picture. The lighting equipment, dollies and everything else were conventional.

**You worked so long on this film, and so much good footage must have ended up on the cutting room floor. Does that bother you?**

**Storaro:** I don't worry about what is cut. It's the concept that is important. Maybe footage that was cut was important because it created a mood leading to something we shot that was used. You make a movie step by step. What counts in the end is what is on the screen. In the picture that I am doing now, *Reds*, we may shoot two million feet of original negative before we are finished. While I am shooting each scene, it is very important to me. In the end, I will care about what is on the screen.

**Tell us a little about that film.**

**Storaro:** It is the story of an American journalist who went to Russia during the revolution, and wrote a book called *10 Days That Shook the World*. He went back to Moscow in 1920, where he died and was buried in the Kremlin. Warren Beatty is directing and star-

ring. We are shooting mainly in England, but also in Finland and Spain.

**What's next for you? Is there something that you would like to do in the future?**

**Storaro:** It is very difficult for me to think of what I want to do when the movie that I am doing now is always foremost in my concentration. However, it happens that there is a film I have wanted to do for 12 or maybe 15 years. Sometime during the mid-1960s, I saw an exhibition in Paris of the comic strip drawings of Edgar Rice Burroughs' story *Tarzan and the Apes*. At first, the drawings captivated me. I fell in love with the design. It reminded me in some ways of the Italian masters. I envisioned a magical, fantastic, unrealistic jungle. I was discussing this one day with Coppola at his home in San Francisco, when he introduced me to Robert Towne. He said, "Guess what he is doing? He is writing a script for *Tarzan*." We have done some tests, and I would very much like to do this movie. I have some ideas in my mind, but they are only the first vision.

**We asked you earlier if you have a particular style of cinematography. Would you mind elaborating on that a little more from the point of view of how you approach a new movie like *Reds* or perhaps *Tarzan*?**

**Storaro:** It is difficult for me to speak about myself in this way, very difficult. I try to be totally open when approaching a new film. I try to develop a look or style which fits the concept of what the director is trying to achieve. It doesn't matter to me what the style of cinematography is, classic or realistic lighting or whatever. Once you find a style that works for that film, you develop the look one scene at a time. It's like a book with many pages. It's the book that counts, not the individual pages. With today's cameras and fast lenses, the negative film that we have, and other equipment, we can write with light in any way we choose.

**Surely, you knew that with *Apocalypse Now,* you had made an outstanding film that would at least be nominated for an Academy Award? Tell us how you feel about this. Are you excited?**

**Storaro:** Being nominated for an Academy Award is very important to me — just the recognition of anyone coming up to me and saying, "I saw your film, and it made me feel something is important." When your peers in the industry say this, it's even better than winning. Being one of the five cinematographers selected by the other cinematographers is very significant to me.

**Three of the five nominees are Europeans this year. Do you attach any significance to this?**

**Storaro:** I hope that this is a sign that theatrical filmmaking will become more of an international industry. I believe that we can all learn a great deal from each other.

First published in *American Cinematographer* magazine, May 1980.

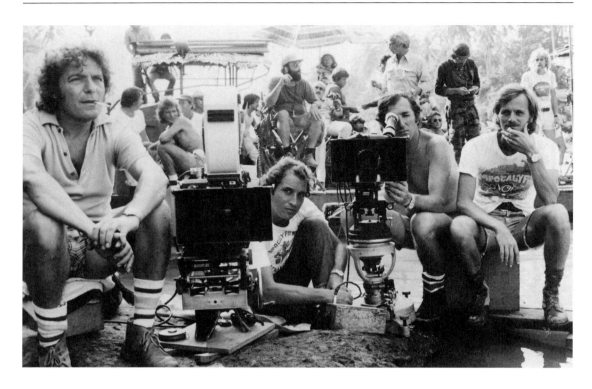

Storaro (kneeling at center) and his crew line up two cameras on location in the Philippines. Flanking Storaro, from the left, are camera assistant Rino Bernardini, operator Enrico Umetelli and camera assistant Mauro Marchetti. In the background, Francis Coppola (seated) chats with assistant director Jerry Ziesmer (white shirt) as Dennis Hopper (in camouflage pants) finds his motivation for the scene.

# 2

# *Jerry Ziesmer on Working with Storaro*

**Editor's note:**

The following two excerpts are taken from Jerry Ziesmer's excellent autobiography *Ready When You Are, Mr. Coppola, Mr. Spielberg, Mr. Crowe.* Ziesmer was the assistant director for the major film directors and cinema artists of our age for many years, and he writes about his experiences in his book.

The anecdotes here deal with with Ziesmer's work on *Apocalypse Now* and provide a wonderful picture of what it was like to work with Vittorio Storaro on that classic film.

## Dinner with Vittorio

It was Saturday, and we had just finished filming the last of the coverage on Robert Duvall's scene in Village 11. For an assistant director, Robert Duvall is a dream to work with because he's so dedicated to the picture and his role. I wished he was in more of *Apocalypse Now.*

We shot a bit late, and Francis and Vittorio had to spend the night in Baler; it got a bit too late to fly to Manila and make it there before dark.

Larry was busy with the extras, and I was just waiting around, enjoying the fact that the week was over. We filmed six days and had every Sunday off. I wondered what people could do in Baler on Sunday; there didn't seem to be much of anything there.

"Jerry." It was Vittorio. "Can you come to our house tonight for dinner?" The Italians had one large house in Baler, and that's where they all stayed, including Vittorio, when he couldn't fly back to Manila.

"Dinner? Well, yeah, I guess so. Thanks, Vittorio," I stammered. I wasn't much on social graces. I knew my job, baseball, fishing, but I didn't know dinner with the Italians.

"Good, Jerry." Vittorio was the Roman gentleman even on the beach in Baler. "About eight?"

"Sure, Vittorio, thanks. Yeah, I'll be there," I answered. "Ahhh, can I bring something?" I discovered some social grace I must have picked up around a dugout.

Vittorio stared at me, smiled, and said, "What? What, Jerry, could you bring? This is Baler!" He laughed, and I did, too.

"Eight. I'll be there."

I got back to our room and showered as quickly as I could. I was just finishing getting dressed, when Larry came in.

"Hey, Jet, where you going?" he asked.

"Dinner with the Italians," I answered.

"Oh." Larry looked at me and sat down on his bed. It was obvious he wasn't invited.

"Just a little dinner. Something, I don't know. Vittorio asked me," I went on.

"What are you going to bring?" Larry asked.

"Vittorio said I shouldn't bring a thing. I have nothing to bring anyway," I said.

Larry jumped and ran to the corner of the living room that contained the hot plate and icebox. He returned proudly.

"The hell you haven't. You got this!" he proclaimed, as he held a bottle of Italian red wine vinegar.

There were no lights except on the main street of Baler. I had to stop and ask at least six different people where the Italians lived, but they all knew and pointed me on my way.

When I got to the house, I knocked, even though the door was partially open. Macro, the Italian camera assistant and also the son of the key grip, answered the door, and I entered. The small house was crowded with all the Italians from the camera, grip and electric crews. I looked around, trying to find Vittorio; I thought that's who I should give the bottle of red wine vinegar to.

"Jerry Z!" Luciano, the electric gaffer, shouted to me. The Italians were so wonderfully gracious and social off of the set. They all started to greet me and smiled their warm welcome.

"Where's Vittorio?" I asked as I held the bottle.

They pointed to the kitchen, and I made my way over to it.

There was Vittorio, tasting the sauce for the pasta. He could have been Marcello Mastroianni, the most Roman of all Romans. Vittorio was dressed in an open shirt with a gold chain, tailored slacks and loafers. It was like he had just paused in this kitchen long enough to taste the pasta sauce, and then he would continue walking along Rome's Via Veneto.

"Jerry, good," Vittorio said. "Nice to see you." Italians are so gracious.

"Here," I said as I handed him the bottle of Italian red wine vinegar. You would have thought I had handed him the last bottle of vino in Italy.

"Alfredo! Mauro!" Vittorio called as he held up the bottle. "Look, for the salad!" It seemed like the kitchen filled with half the Italian crew admiring my gift. The bot-

tle found its way to Mario, Alfredo's other relative, who was in charge of the salad.

I saw someone who was obviously the chief cook. He was Italian, but I hadn't seen him during the filming. Vittorio saw me looking at him, and he introduced us.

"Jerry, I want you to meet Fabrizio, our extra electrician. Fabrizio, this is Jerry, our assistant director from Hollywood."

We shook hands and smiled, but why did Vittorio have to introduce me to an electrician when we've been filming all week? Why hadn't I met him on the set?

Vittorio saw my confusion, and he took me aside. "Jerry, Fabrizio is our 'extra' electrician, our cook! Do you understand?" Vittorio said and laughed.

"You have an extra electrician. You've brought him all the way from Italy to be your cook," I said, just to get all straight in my head.

"Yes, Jerry, and wait until you taste the sauce!" Vittorio said, and moved around the kitchen, sampling the salad.

The dinner was fantastic, with perfect pasta and sauces, freshly baked Italian bread, salad with Italian red wine vinegar. We all sat around the living room, balancing our plates as they chatted, mainly in Italian, with frequent interruptions for laughter and smiles. I couldn't understand much, so I got up after a bit and wandered over to a corner of the room that was set up like a reading area, with a rough chair and large wooden coffee table.

The table had large books of artists' works on it. I glanced around at the happy group and, feeling I wouldn't be missed, I sat down and opened one of the books. Suddenly Vittorio was standing right next to me.

"Jerry, you like art?" he asked.

"Yeah." I felt like he had caught me doing something I shouldn't have. Maybe in Italy you don't look in other people's books in their homes.

"Each movie I do, I study one artist," Vittorio said.

"Really? Why?" I asked.

"After I have read the script, I search for an artist for that film," Vittorio continued. "I look through all the artists until I find the one who 'speaks' that film. Do you understand, Jerry?"

I looked at Vittorio. I felt it was like my moment to be talking with Renoir or maybe Rembrandt. I wasn't going to miss it.

"I don't understand," I said. "Explain it to me."

"Look, Jerry," Vittorio said, as he took out a large volume and put it on the table. "After I read *Apocalypse* I talked with Francis, then I began to think of artists. Who speaks *Apocalypse Now*?"

"I don't know," I admitted; I was way out of my league.

"Paul Gauguin. You know him? Look, Jerry," and Vittorio opened the huge art

book and turned to a work by Gauguin. It was Gauguin's allegorical painting *Where Do We Come From? What Are We? Where Are We Going?*

"Jerry, look at the jungle leaves," Vittorio began; the tone of his soft voice seemed to stroke the painting. "See all the greens? Look at just the dark greens. Ah, Jerry, see?" That Gauguin painting shows lush jungle vegetation, animals, birds and natives; it even shows a Buddha-like statue.

"Look, Jerry, here. See the bright yellow, the red ... . This is the color from Joe Lombardi's smoke grenades, you know?"

Vittorio was trying hard to make me understand. I wasn't sure why.

"See here, the dark greens. Brooding jungle, Jerry. Like in *Apocalypse Now*. See here, the darkness, the danger, the fear? Brooding, you understand?"

"And this speaks of *Apocalypse*?" I asked.

"Yes, the colors ... look, Jerry," he continued, as he had gotten some news magazine photos of the Vietnam War. He pointed at the bright-colored smoke grenades against the dark of the jungle vegetation. "Look at the photo, Jerry. Now look at Gauguin. You see? It's the same."

Vittorio smiled, the art master with a street urchin, but he never talked down to me. I always felt Vittorio was totally sincere in communicating his ideas and feelings to me.

"The light! Jerry, see the light?" Vittorio was pointing at the Gauguin work.

"Light?" I asked. I didn't really see any bright sunlight.

"Yes, the light! It's the energy, the life. Life itself. Light! Look, Jerry," my teacher continued, as he stroked the painting, showing me the flow of light. "See?"

Suddenly I became aware of silence. I turned quickly, and everyone in the room was listening to Vittorio and me. They smiled as I stared at them, and then Vittorio smiled and patted my shoulder, then everyone laughed and the party continued. I don't know how long the party was suspended for my art lesson. Then I closed the book and sat back in the chair and watched the Italian crew as they enjoyed the night.

## The Magic Hour

Gambi [the tiger] came to us in Baler to work in a scene with Fred Forrest and Marty Sheen. In the script, the PBR [river patrol boat] was docked on the side of the river for routine maintenance. Chef wanted to go into the jungle and get some mangoes. Willard said he'd go with him for protection, while Lance, Clean and the Chief would complete the maintenance on the riverboat's engine. Chef and Willard then

searched through the jungle, but instead of finding mangoes, they found a tiger. The scene ends with Willard and Chef running back to the boat.

Vittorio had broken up the scene into three portions. First he wanted to film all the shots on the boat, leaving the boat, and returning to the boat. All of these shots were to be done on the first day. Then Vittorio wanted to do all of the shots of Chef and Willard moving through the jungle looking for mangoes on the second day. These shots were vitally important to Vittorio; he wanted to work his cinematic artistry to create the jungle of Gauguin. The final section Vittorio wanted to film was the confrontation with the tiger, our Gambi, which would be done on the third day.

Both Francis and I thought Vittorio's plan to film this sequence was fine. We all agreed, and the first day we filmed everything to do with the boat. Vittorio sent his electrical crew and most of his grips out into the jungle to prelight the next day's work: Willard and Chef walking through the jungle.

All during that first day, different Italian crew members would come back to Vittorio from having been in the jungle, and they would whisper to Vittorio, receive instructions from him and then scurry back into the jungle. I was curious as to what was going on, but I had my hands full with the PBR cast and getting the day's work.

After about the sixth messenger ran to Vittorio, spoke to him, received Vittorio's reply and ran back into the jungle, Francis took me aside.

"Jet, what's going on?" he asked, looking at the departing Italian crew member.

"Just working on prelighting tomorrow's work, I guess," I answered.

Francis stared at me. "Then why are they whispering?"

I stared back at him.

Francis laughed, "Why aren't they using their walkie-talkies? Answer me that!"

I looked at Vittorio, then at Francis. "What's he up to?" I asked. Francis had gotten me terrified because I remembered my experience with Vittorio's dolly track in the ocean.

"I don't know, and I'm Italian," Francis said, and moved away.

The shooting on the boat went great. We finished the day's work on time, which is the primary responsibility of the assistant director. I was happy as I called a wrap and the company prepared to go back to Baler.

The next day we arrived out at location, and I had Larry get Marty and Fred Forrest ready to film. I saw Vittorio talking to his crew, so I joined them. Vittorio was speaking in Italian to his whole crew. Everyone was there, even Fabrizio, the cook. The mood of Vittorio's speech to his crew was both like a tense NASA countdown to launch and like a brain surgeon going carefully over every detail just before a very critical operation. Vittorio spoke in Italian, so I couldn't understand a word, but I was impressed anyway. Alfredo, Luciano, Mauro and everyone were listening with bowed heads, nodding gravely, and glancing back to Vittorio. I wished I understood Italian; it

was obviously a moving speech by Vittorio.

Then the fear hit me; I pulled Enrico to one side and whispered to him, "Enrico, did someone die? Someone's wife or family?"

"No, Jerry," Enrico whispered. "Vittorio is just explaining today's work."

Now I was scared. Vittorio never explained the day's work. For the most part Vittorio preferred to wing it; he came out in the morning and lit the scene as he was inspired. He was an improvisational artist, not a calculating brain surgeon. I looked at Enrico, but he had rejoined the circle around Vittorio and had bowed his head.

Soon Vittorio finished, smiled at his crew and walked casually away. The crew loitered around, not doing much of anything, They certainly were not working feverishly to prepare a shot for Vittorio.

As soon as I saw Francis, I got him with Marty and Fred to rehearse. Vittorio joined us, and some of the Italians wandered over to watch. The first little sequence was Willard and Chef looking through the jungle. Francis showed us the first shot, and the actors did their action. Vittorio saw, nodded, and no one moved, not Vittorio or his crew.

"Francis, can we see what happens next, please?" Vittorio asked.

Francis glanced at me, but it wasn't really anything unusual for a cameraman to see what shots were coming next, so Francis moved deeper into the jungle, and he showed the next little sequence of the actors moving further into the jungle. The actors did the action.

Francis nodded at Vittorio, "That's it, Vittorio."

"Francis, can we see what happens next, please?" Vittorio asked.

Again Francis and I exchanged a glance, but I had worked with cameramen who just liked to know what was coming up.

Francis marched us further into the jungle and showed the next little scene of walking through the jungle. The actors did their thing, and Vittorio again wanted to see more.

This continued until we had marched all through the jungle and had shown Vittorio every shot we had to do that day, twelve shots. I urged Francis, the actors and especially Vittorio that we did have a lot of work to do, but if we got a running start, an early start, I felt we could get it done. Francis and the actors nodded and went back to get ready; Vittorio silently walked into a tiny jungle clearing, and his entire crew surrounded him.

I looked for Francis; he understood Italian, and I needed to know what Vittorio was talking about. Francis was gone, so I walked over to Vittorio and his crew. As I got close, Vittorio looked at me and stopped speaking Italian.

"Hello, Jerry, how are you today?" he asked.

I want to tell you what I experienced behind my eyes. I saw red warning lights,

I heard European-style sirens, I saw red-blue-gold spinning lights. Vittorio had me panicked; what were they up to?

I smiled, nodded and said I was fine. No one moved; they all just stared at me. I felt embarrassed or out of place, so I turned and walked back toward the jungle area of our first shot.

"We'll begin back down here, right, Vittorio?" I called back.

"Yes, Jerry, of course," Vittorio answered. The whole Italian crew had turned to look at me again. It was about 8:30 a.m.

I stood at the jungle site for our first shot, and I was alone. No one was there. No, Vittorio, no crew, nobody was there.

"Larry!" I called on my walkie-talkie. "Larry, come in."

"Yeah, Jet," Larry answered. He was back near the boat, the actors, and Francis.

I had to be careful, because I never knew who was listening to our walkie-talkie.

"Larry, I'm lonely here."

"Where are you?" he asked.

"I'm at the first location, and there's no one here." I was careful.

"Oh, yeah. Well, I don't see anyone here, either," Larry answered.

"What! Where is everyone?" I said.

"Jet, there's no one here. I thought the crew was with you!" Larry answered.

At 10:30, I was still standing at the mark for our first shot. Still no one was here. I had seen some of the Italians moving through the jungle, but no one seemed to be doing anything to get the first shot ready.

"Larry!" I called him again on the walkie-talkie.

"Yeah, Jet."

"Larry, I'm coming down to talk with Francis," I said, and started through the jungle toward the boat.

I found Francis sitting on a fallen log, throwing bits of bark into the river. I walked over to him.

"Francis?" I said.

"How are we doing? We ready yet?" he asked. He kept breaking off tiny pieces of bark and throwing them sidearm into the river.

"No, we're not," I said.

"How long you figure?" Francis asked.

"I don't know; I can't find Vittorio or the crew." I expected Francis to react, but he just sat there and threw bits of bark into the river.

"They're up to something, Jerry. We'll know soon enough. When's lunch?" he asked as he looked at me for the first time.

"We have to eat at one," I answered, even though I was getting numb and tones

were vibrating around my head.

"Good. Call me when it's lunch, Okay?" he asked, and he returned to throwing pieces of bark into the river.

I walked slowly away, stunned that I couldn't find the cameraman or the crew and that the director didn't seem concerned.

I walked back up to the location of the first shot, but the only people there were Marty and Fred.

"Still working?" Marty asked as he looked at the empty jungle.

"Be a bit," I answered.

Fred Forrest was not so kind. "Where the hell is everyone! It's almost lunch!"

"Come on, Fred," Marty said, and led him back down toward the river.

Just before 1 p.m. I called lunch over the walkie-talkie, walked down to tell Francis, and had Larry shout that it was lunch all through the jungle.

Amazingly, everyone came to the lunch line to get a boxed lunch. All of the Italians were there. Vittorio was there. They were chatting and happy, as though it was just any ordinary day. The boxed lunches were worse than the normal lunches, but the Italians were happy all during the lunch break.

When Larry and I felt that everyone had had an ample time for lunch, we called the crew back to work. Everyone stayed seated. Then they got up slowly. Then they walked slowly toward the jungle. I looked toward Francis. He had been an assistant director; maybe he could help me.

Francis always appreciated that I told him exactly why we had a delay. I always did that. I walked toward him, but before I could speak, he said, "Jet, I don't know what's going on, and I don't want to know. Let's just go with it."

What the hell did that mean? I started to say something, but Francis held up his hand for me to stop, and he walked back toward his fallen log by the river. It was just after 2, and we hadn't gotten a shot, hadn't gotten the camera to the set, hadn't gotten anything but a box lunch! Tension tears me up inside sometimes.

I walked back up into the jungle and sat down at the exact location for the first shot; no one and nothing was there. I was totally alone. "Let's just go with it," Francis had said, and that was exactly what I was going to do.

At 3, I took out my walkie-talkie and called Larry. "What's happening?"

"Nothing," he answered. "You see the crew?"

"No."

"You see Vittorio?" he asked.

"No."

"I'm glad you're here, Jet," he said.

I waited. At 4, I called Larry again. He saw no one; I saw no one.

At 4, Marty and Fred visited me and then went back down to the river.

At 4, a single figure moved through the jungle about one hundred yards from me. I tensed and watched it. The figure would move, stop, raise its arm; move, stop, raise its arm. The figure walked across my view from right to left, then he came slowly toward me. It was Vittorio. He had his light meter in his hand.

I stood up when he was about thirty yards from me and walking slowly toward me, step by step. There wasn't a sound in the jungle. Only me standing and Vittorio walking step by step toward me as he stared at his light meter.

Vittorio came closer. Finally he stood where the camera was to be for the first shot. He stared at his light meter.

"Hello, Jerry, how are you?" he asked, as though we were seated at a Roman cafe having a cup of cappuccino.

I didn't move, breathe, or speak. I just stared at him.

Suddenly, as if lightning had hit him, Vittorio began to shout, "Alfredo! Luciano! Mauro! Enrico!"

I looked around me, and the Italian crew came running through the jungle toward us as they shouted, "Here, Vittorio! Here!"

Vittorio turned to me with utter urgency in his eyes, "Jerry, we must film now! Right now! Have Francis and the actors run up here now!" He was shouting at me and at his crew which was running madly around setting cameras, lights, dolly track all at once.

"Larry!" I shouted into the walkie-talkie, "Have Marty and Fred and Francis get up here right away!"

Vittorio grabbed my walkie-talkie from me. "Excuse me, Jerry," Vittorio said graciously to me, but then screamed into my walkie-talkie. "Larry! They must run now! They must run! I only have thirty minutes of light and we must do twelve shots!!!!!"

Thirty minutes of light for twelve shots, I had heard Vittorio say. We had sat doing nothing all day, from seven in the morning until five at night, and he had only thirty minutes of light for all twelve shots?

"Vittorio? What are you doing?" I begged.

Vittorio was like a madman, shouting orders to his crew, looking through the camera, checking his light meter.

I looked and saw Francis, Marty and Fred running through the jungle, chased by Larry Franco.

"Francis! We must go!" Vittorio shouted.

"Okay" Francis said, and nodded at me as if to say, "Didn't I tell you?"

Vittorio shouted to his crew, moved Marty and Fred into place, put Enrico behind the camera, called to roll the film, shouted "Action!" for the actors, and helped Alfredo move the dolly along its track.

As soon as the shot was over, Vittorio looked at Francis for a split second. Since Francis seemed to like the shot, Vittorio stormed ahead through the jungle toward our second location. The Italian crew ran ahead, not bothering to take the camera off of the dolly, but carrying the whole thing, dolly and camera with lens, through the jungle. Everyone was running and shouting and scurrying. Marty and Fred were in shock, which I thought might work for the scene.

Francis just came plodding along through the jungle, and just as he got to the camera, Vittorio was shouting, "Roll film," then "Action!" As soon as that shot was completed, he ran wildly ahead to the next shot, with the Italian crew madly in pursuit. Everyone was shouting and running through the jungle. And so was I.

I have never experienced anything like it. We continued to run, then shoot, then run again, then shoot again, until at 5:30 we got our twelfth and final shot of the day.

The crew was lying all over the ground; they were totally exhausted. It had been like a one-mile sprint for them while they carried all of our equipment on their backs.

Marty and Fred were staring at all of us; they could not believe what they had just experienced. Francis was calm. I don't know how he did it. I was exhausted, frightened and adrenalized all at once.

Vittorio took a deep breath, then walked up to Larry and me. He put his hands on our shoulders and said, "Thank you. The lighting was magnificent!"

I stared at the crew and equipment strewn around us as I watched Vittorio grandly stride through the jungle, once again the cultured Roman artist sauntering along the Via Veneto.

excerpted from:

*Ready When You Are, Mr. Coppola, Mr. Spielberg, Mr. Crowe*
by Jerry Ziesmer
(Filmmakers Series, No. 69)
Scarecrow Press
4720 Boston Way
Lanham, Maryland 20706,
ISBN 0-8108-3657-2

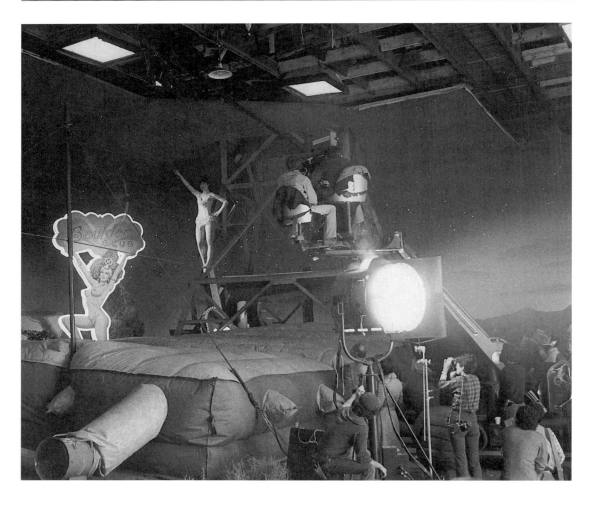

Nastassia Kinski, starring in Francis Ford Coppola's *One From the Heart*, does a wire-walking stint before the crane-mounted camera while a huge air bag below safeguards her from injury.

# 3

# *Mating Film with Video for One From the Heart*

Francis Ford Coppola relied heavily upon the electronic medium to pre-shoot and pre-edit, thus saving time and money.

As the January 1982 issue of *American Cinematographer* went to press, down-to-the-wire postproduction was nearing completion on Coppola's long-awaited production of *One From the Heart,* described as "a fantasy about romantic love, jealousy and sex." It stars Frederic Forrest, Teri Garr, Raul Julia, Nastassia Kinski, Lainie Kazan (all members of Zoetrope's "repertory company") and Harry Dean Stanton.

*One From the Heart*, which Coppola directed, marks the first film to be made by Zoetrope Studios utilizing the first-stage technology of "electronic cinema."

Coppola first publicly heralded the advent of electronic cinema at the 51st Annual Academy of Motion Picture Arts and Sciences telecast (April 9, 1979), when he said: "We're on the eve of something that's going to make the Industrial Revolution look like a small, out-of-town tryout. I can see a communications revolution that's about movies and art and music and digital electronics and satellites, but above all, human talent—and it's going to make the masters of the cinema, from whom we've inherited this business, believe things that they would have thought impossible."

Still in its early development, electronic cinema makes possible the "previsualization" of the planned film. This begins with the process of optical transfer of storyboard sketches onto a video disc. Then the recorded dialogue of the film, plus music and sound, are added to the disc, producing a pictorial and audio form of the script months prior to the start of filming. With the commencement of principal photography, electronic cinema enables the filmmaker to view each scene on video monitors while it is being shot. The process further allows the director to control and adjust all of his elements—lights, camera moves, direction and even editing—as he shoots.

*One From the Heart* features songs and music composed by Tom Waits, and dance sequences choreographed by Kenny Ortega under the guidance of Gene Kelly, executive for musical production for Zoetrope.

*One From the Heart* marks the first time in recent motion-picture history that actual existing locales have been recreated on Hollywood soundstages. Over a period of, 4 months, more than 200 craftsmen worked at constructing the city of Las Vegas—suburban streets, motels, apartments, a department store, McCarran Airport Terminal, four corners of downtown in full scale, plus the Las Vegas Strip with all its neon glitter in miniature. Thus, Coppola was able to direct the film with total control over the environment's elements, such as time of day, weather and traffic.

Under the aegis of Academy Award-winning production designer Dean Tavoularis, attention was paid to even the smallest detail on sets that eventually utilized eight of Zoetrope's nine soundstages. The downtown Las Vegas set, which occupied Stages 3 and 8, used more than 125,000 light bulbs and over 10 miles of flashing neon.

Capturing the excitement of this dazzling cityscape under the studio roofs was Vittorio Storaro, who brought his brilliant cinematographic technique to *One From the Heart* as he did so strikingly on *Apocalypse Now*, for which he received an Academy Award.

When *American Cinematographer* asked Storaro to describe his approach to the photographic visualization of *One From the Heart,* he said that he would prefer that the magazine publish a statement which he had previously prepared for another publication and which precisely expresses his views. Acceding to his request, we are publishing word-for-word the following statement: "It is an attempt of reunification between two different energetic poles, two natures that are equivalent even though they belong to opposite signs, both being part of what we call the visible light: the life. Male and female; positive and negative; nature and technology; night and day, heat and cold; light and shadow. For the theory of the contrast, these colors being contrastingly close, intensify, starting a continuous conflict of personality; they could very well co-exist, but they fight because of the fear of being overwhelmed by the other until the awareness that their moving energy unequivocally leads to the conjunction of their spiritual forces.

"It is as if seeing the components of light, separated by the prism of the life in that togetherness of radiations of distant wavelengths that are called 'colors,' and then rejoined through the lens of evolution in a white light, is our aim: the equilibrium, the maturity. The theater of this conflict: Vegas, like the representation of the affirmation of a part of the civil world on nature, the light on the desert. The sunset, like the loss of the sun, is the loss of awareness; Vegas rises with the moon, like the primitive element.

"On Saturday evening, the organisms, with the necessity to disperse energy through activity, search the bright colors. The lights of Vegas break the equilibrium of nature, change the heartbeats, increase the metabolism. Colors such as 'RED,' the symbol of conquest, lights above the town, has the tendency of increasing the blood pressure; 'YELLOW' and 'ORANGE' stimulate the nervous vascular system and the

cardiac frequency.

"The Saturday evening is the revealer of the forbidden dreams of the unconscious, a removal of our hidden side.

"If the nature, during the dusk, brings a respite from emotions, towards a physical and psychological need for rest, the 'GREEN' of conservation and the 'BLUE' of the night that have a regenerative effect, lead the autonomous nervous system towards a decrease of its functions, a reduced hormonal secretion; Vegas has a catabolic effect. Its lights and its colors impose the renewal of the interrupted activity, the increase of the metabolism and of the endocrine secretions is induced by the high wave length to undertake the conquest on the primitive man.

"The conflict between 'PURPLE-BLUE-GREEN,' the 're-entering' colors, and 'RED-ORANGE-YELLOW,' the 'going-out' colors, is revived. This is the representation ,through colors of the chromatic spectrum, of the emotions and state of soul that distinguish our separate moments of life.

"The unlimited desire of love that exists in mankind leads this togetherness of emotions/radiations to a union in a light that comprises them all, and of which all are a part; the human being is not two separate halves, but the union and not distinction between man and woman, light and shadow, magenta and green, yellow and blue, cyan and red, it is energy."

In his interview for *American Cinematographer*, Storaro went on to say, "The entire film was shot on soundstages. Some night scenes actually shot in Las Vegas were filmed as background plates, and we used a few of these. If we had physically shot the entire film in Las Vegas, it would be a more realistic picture, but it would not be *One From the Heart*. This is a totally unrealistic picture. We are expressing subliminally the emotions of the characters, expressing them in a more theatrical way."

Asked to what extent he had an opportunity to pre-plan his photography, Storaro replied, "From the beginning, our plan was to prepare the picture all at once, not scene by scene or sequence by sequence. We prepared the movie from beginning to end. When we started, Francis and Dean Tavoularis and I sat down and thought about what we wanted to do in the visual sense. We told our ideas to a sketch artist, who made some drawings for each sequence. At the same time, the actors were rehearsing on video and recording their own voices reading the script.

During those three weeks of rehearsal, Dean was able to pre-design all the sets and, since they are all interiors and Francis owns the studio, those sets could occupy almost 100 percent of the stage space.

"After three weeks, we had shot the picture on video from beginning to end. Some of the sequences which had been pre-designed looked very real, but others somewhat

rough, mainly allowing us to understand the principle of the idea. But after three weeks, we were able to see the whole picture in video form and decide which parts didn't work and would have to be changed.

"We tried to use the best ideas from radio, from the theater, from television and from the cinema, and put all this knowledge together. One of Francis's first ideas was to shoot the entire picture on videotape and transfer to film, but I refused to do that because I don't think that the quality of the transfer from video to film is good enough today. But it will be soon. There is no question that in a few years, the movie business will be totally changed as the electronic system becomes more and more improved."

## The Electronic Cinema: The First Stage

Heralding what he calls "filmmaking's greatest leap forward since the advent of sound in 1927," Francis Coppola introduces the first-stage technology of electronic cinema on *One From the Heart*, a process he feels will ultimately revolutionize the way in which movies will be made.

"I sit, I view the screen, I talk to the screen, and the screen does what I tell it to," Coppola says.

Under the auspices of Thomas Brown, formerly associated with Lucasfilm's special-effects team, the electronic cinema has achieved a direct film-to-video relationship whereby a frame-to-frame image of 30 fps (frames per second) videotape can be matched to 24 fps film.

The electronic cinema consists of three main centers of operation interconnected via cables. From the soundstages, where video cameras are attached to film cameras with a standard beamsplitter videotape, and to individual Sony Betamax recorders with connecting monitors, the performance is fed to the Image & Sound Control vehicle.

Fulfilling dual production/editing functions, transmissions are both sent and received from this vehicle. Here Coppola can view and control the action from source monitors corresponding to the cameras and stage monitors, as well as make a "first impression" edit.

It is in this chamber that an audio composite condensed from an 8-track dialogue recording is mixed with sound effects and music and added to the video. Thus, a video-cassette soundtrack approximating the final sound mix is generated during production.

The Image & Sound Control vehicle also serves as the editing center from which a more discrete version of the film emerges. Color videocassettes from the transfer facility are brought to this vehicle, where they are edited on Sony Betamax units to conform to the "first impression" cut. Then a constant re-working of the material occurs, providing a continual upgrading of the accrued footage.

The transfer facility contains a Videola, time code reading and writing equipment, a video control console and videotape recorders. Here the camera's film is transferred to videotape. Information stored includes the film's time code, scene and take number, yellow-edge number and key number.

Throughout the entire filmmaking process, the electronic cinema constantly expands the filmmaker's creative options: the off-line editing system contains instant optical effects and dubbing capabilities, which enhance the filmmaker's creative choices.

The filmmaker's conception of the movie is improved as the script in its sequential moving form, is available months prior to the start of filming. This is accomplished via a previsualization process in which storyboard sketches are transferred to an electronic video still store. Then the dialogue and sound effects previously recorded as a "radio play" are transferred to ¾" videocassette. As these elements are mixed, a crude but conceptually effective motion picture evolves.

Each new step in the electronic storyboard process enhances the filmmaker's conception of the film, so that a constantly refined and refreshed point of view actively engages the filmmaker's creativity.

By the time principal photography starts, the filmmaker possesses a judicious and carefully formed opinion of his true intent of what his movie should be.

Remarkably cost-efficient, electronic cinema radically reduces postproduction editing time, thus significantly diminishing interest charges on investment capital.

Creatively, electronic cinema allows the filmmakers to continually preview the film. This advance opportunity to "see" the film leads to a tightening of the script and elimination of unnecessary scenes and sets, further cutting the cost of the movie.

The state-of-the-art electronic cinema was utilized in the making of *One From the Heart*, which Coppola directed from the Image & Sound Control vehicle. He feels that when audiences see the film, they will be viewing the result of the latest step in the evolution of the cinema.

First published in *American Cinematographer,* January 1982.

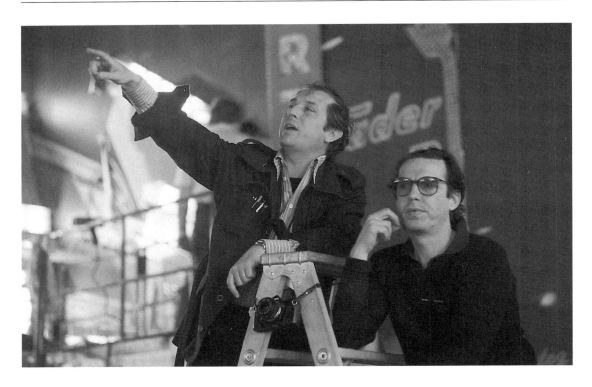

Storaro directs placement of a light on *One From the Heart* as camera operator Ron Garcia stands by.

# 4

# The Steadicam
# and One From the Heart

The inventor of the Academy Award-winning device tells
about weeks of working with meticulous artists
Francis Coppola and Vittorio Storaro

by

## Garrett Brown

The first day of so-called "technical rehearsal" was full of surprises, both pleasant and fearsome. I had last seen Vittorio Storaro on the far side of a pair of water buffalos driven by cheerful, non English-speaking types who were herding me out of control toward huge, burning effigies by a train on a plain in Spain for Warren Beatty's *Reds*. I had been looking forward to working with Vittorio for Coppola on a more mundane subject, on the completely controlled sets for Francis's completely controlled Zoetrope Studio's *One From the Heart* — a simple human story — a parable of love and jealousy set amid the barbarous jangle of re-created Las Vegas.

I was aware that the film had already been exhaustively rehearsed, first as a radio drama set to animated storyboard sketches and Polaroids, and then as a crypto-video-play shot as rapidly as a soap opera in "genuine" Las Vegas. Technical rehearsals provided yet another chance to shoot the entire movie without rolling film; the real shots on the real sets with the real cast, to be edited from the video-assist images almost as we progressed.

### Technical Rehearsals

Now began the careful blocking and debugging of the final sequences, including a number of elaborate tracking shots originally designed to permit the actors to carry on through large hunks of script, photographed by a choreographed succession of

cameras: hiding from each other, popping out from closets, swinging by on cranes, rising up through the floor or dropping from the ceiling. (In practice, most scenes ended up being shot by one camera at a time, because neither Francis nor Vittorio was ultimately willing to compromise the staging or lighting to effect the successive-camera scheme.) The idea anyway wasn't to dazzle folks with our footwork. I was happy to find, for instance, that the intended use of the Steadicam was not as a stunt camera, but just to help get the lens where it was wanted throughout some long stretches of the story, without arbitrary cuts because of doorsills, tight quarters, steps or bumpy terrain outdoors.

For the budget, and/or perhaps because of a slight excess of enthusiasm for my operating ability, it was decided that the Steadicam would only need to be on hand for the first few days of rehearsals. I could practice the early shots, and when I returned for production I could alternate between shooting and rehearsing what I missed with the second team. This dubious plan meant that after my departure, Vittorio would have to impersonate the Steadicam when required with a tiny, handheld video camera (with which he became almost too adept at threading his way through the sets).

Calmly, as if explaining the benefits of artillery to an aborigine, Vittorio then told me that several of these shots would also require the new 20-60mm Cooke-Varotal zoom to be mounted onto the Arriflex 35BL, so the focal length could be eased in and out as needed; a wide panorama here, a traveling close-up there. This was a first! The lens had not actually shown up yet, but I was assured that it was tiny and weighed little more than a linguine. When it finally arrived, it appeared to my feverish brain to be about three feet long and made of depleted uranium! In use it didn't prove to be as heavy as expected, but I did notice that I had to plan ahead if I wanted to stop moving, or I would be carried on right out the studio door!

Some of my shots were to run on for over four minutes, and I knew from experience that although the results can be wonderful, this kind of shooting becomes a strain on both players and crew because of the increasing possibility of error, artistic or technical, as one gets down to the final strokes. No one is quite so disconsolate as the Steadicam operator who rounds the final corner after 450 feet of flawless Eastmancolor to find that the wrong door has been left open or a lamp has burned out. Vittorio was designing such elaborate lighting cues that the electrical department alone would be engaged in a flat-out odyssey just to get through some of these scenes.

My last hope of tranquil days ambling through easy, linear shots disappeared with finality when I tried The Elevator, an $18,000 scissors-type contraption which rose from a concealed hole in the floor and lifted two intrepids up through a hole in the ceiling and back down. In the middle of a complex shot, I could step aboard and rise up to the second floor in "Hank and Franny's house" to arrive at the same time as whoev-

er was climbing the adjacent stairs. This would, of course, yield a less drastic angle than if I also climbed the stairs in front or in back of our actors. I was elated with the existence of this device, but depressed by certain peculiarities of its operation. (About which, more later .... )

After three days I left with most of the routine technical matters worked out — the interface of the Technovision lenses with my wireless focus motors, and the reception of the wireless video signal from the Steadicam within the neon-infested confines of the studio were, as usual, the most troublesome. I had a reasonable idea of my first shot: ride down on the crane, dismount, stroll through a mob of extras, up and through the window of a travel agency and down inside for a scene with Teri Garr as Franny and Lainie Kazan as Maggie. With four zooms. Degree of difficulty, 8.4 —Claus Dibiasi watch out!

## Coppola and Storaro

Francis Coppola is an acknowledged master of the film medium as it is presently constituted. However, he is gifted (or cursed) with the ambition to innovate, to advance the art and science of filmmaking and drag the medium singlehandedly into the 21st century. He looks ahead to an era when movies will be digitally recorded as high-resolution video, edited strictly by computer-juggling trillions of binary numbers and distributed by transmitting the ultimate numbers via satellite to exhibitors, or even straight to subscribers in the home. Francis will, of course, direct by satellite from Shangri-la or space shuttle, with actors in San Francisco, sets in New York and lunch in Rome. I believe, as do many, that he is a sensitive, artistic human being, but he is clearly here on earth somewhat ahead of his reservation.

Vittorio Storaro seems to have arrived several centuries late. A throwback to the high Renaissance painters — Correggio with a light meter. A gifted technician by necessity, his stated passion is the discipline of light and image to the needs of the film, and his technique, however theatrically comprehensive, is subordinate to these larger pictorial ambitions. Not to mention that he's a charming, highly civilized character.

These two very different figures managed to work together with a remarkable harmony of purpose, and put up with each other's varied obsessions with amazing fortitude.

## Production

As production began, it was immediately evident that no amount of technical rehearsal could have locked up this movie once and for all. Nor perhaps was it intended to. This is a highly organic style of filmmaking, and the number of options remained nearly as large as life itself. I think even after it's released, I will be surprised

to see exactly the same movie in any two different theaters!

Like all innovators, Francis risks failure by shouldering the burden of debugging his new technology for those who follow. On *One From the Heart,* his technical revolution is more or less underway. Even during final production, all takes were recorded on time-coded video assist, including mine, which were sent by wireless transmitter, and edits could be made immediately on ranks of Betamaxes in the elaborate video van parked on the set. The immediate purpose again seemed to be to help decide what was really working and what the hell to do next. The ultimate purpose was to speed up the postproduction by reference to the computerized edge numbers shared by film and video alike.

From the van, Francis directed by spy camera and live microphone and video assist, and made his wishes known to actors and crew by huge speakers in the rafters or a complex intercom system. Sound effects and music cues could be instantly piped in. For better or worse, he generally refused to stay on the set as a "traffic cop." Curiously, in the midst of all of the gadgets, including mine, he still seemed able to concentrate on the performances from our excellent cast and the nuances of the story, despite the fact that even his quietest remarks arrived like messages from Olympus.

Vittorio managed to function with great spirit amid the reverberations from this sort of Big Brother remote-control, but I think he was happiest when Coppola could be enticed to the set. When Francis was around, even the technical stuff seemed to work better. We were driven mad at times by the difficulty of getting a simple playback, due to the layers of "Iso operators" and "Image engineers" that one had to subpoena deep in Tom Brown's amazing electronic cinema department, only to find them involved in mysterious and arcane "other operations" relating to entirely different aspects of the picture. And yet in a pinch, it was great to watch the embryonic control of all of these elements suddenly produce a perfectly synced music cue on the set, or a whimsical sound effect, or a choice edit instantly played back that could be extremely useful for figuring out some bit of business, or to inform key members of the cast or crew what had to be done to get from A to B. For myself, I was now and then yanked back from the brink of amusement by the realization that it works! This is the beginning, and the Innovator must be given some latitude for error, and his due credit … (as has been elsewhere widely reported!)

For his part, Francis supported or sometimes endured Vittorio's penchant for shots that became extravaganzas of lighting, with suns coming up on screen and immediately going back down (slates often read "evening sunrise" or "morning sunset"), and with lights spontaneously fading in and out as Vittorio orchestrated mystical, color-sensitive auras to intensify the actors' personalities and moods with wavelengths that influence fundamental emotional and metabolic responses from the viewer. No one is sure of the final effect of all this upon an audience. We will have to

wait for the reactions from the august and the humble, but I can report that the reaction from Jim Blair and his loyal electricians must have been seen to be believed. They progressed from stunned amazement at what was being required of them, to a form of enthusiasm for the carnival of activity at the dimmer board that accompanied many of the shots in the picture. To no one's surprise, the results seemed exactly suitable to Dean Tavoularis's fabulous, theatrically claustrophobic sets.

Regarding the use of the Steadicam and all of the other tools at the disposal of our "designer of photography," I remain impressed by the consistency of Storaro's vision and the idea-directed nature of his work: infuriatingly self-confident, unswerving, willing to take chances based on careful thinking as well as impulse, he is a phenomenon. He is also, by the way, unquestionably the best scout, guide and line-backer for Steadicam shooting that I have ever come across. In a letter once, I jokingly mentioned that if he ever gets tired of cinematography and desires frequent travel he can name his price to guide me around the circuit! For instance, on the Las Vegas street dance number, as I found myself backing at high speed through narrowing openings between cars and shooting the gap past extras and gyrating dancers, Storaro was always just outside the frame, nudging people out of the way, warning sotto voce of the oncoming curb and the next three obstacles, cueing cars, zooms, lights, dialogue and the crane, while conducting a running dialogue about the upcoming compositional opportunities.

I had a great time working again with the Italians on Vittorio's crew. His operator, Enrico Umatelli; the assistant, G. (Roberto) Alberti; and the grip, Alfredo Marchetti, are respectively masters of their professions, and were once more greatly helpful to me on this picture. I hope some day to be able to work with them on their home ground. It was a revelation to watch these guys making highly complex shots with the Elemack-supported jib arm (which I may even end up getting credit for from any rabid Steadicam afficionados). It is a humbling experience to watch them getting an incredibly difficult shot in the first take or two with no fanfare, just a muttered undercurrent in Italian; probably a discussion of the weather. They worked closely and harmoniously with the large and excellent American crew and provided an international atmosphere to the job which I think is still too rare in this country.

Storaro thoroughly understands the conventional machinery of filmmaking, and it was difficult for me to feel too indispensable as I watched a dolly shot he designed, operated by Tom Ackerman, which ran 10 minutes and involved some amazing choreography: entire sets appeared and disappeared behind walls (which turned out to be scrims) as the dimmers rode up and down and the dolly traveled back and forth between at least 30 different camera positions. This with a BNC, folks, on a Vinten head. I found myself sitting on the sidelines chewing on the arm of a director's chair, wondering if I could have gotten this baby even if I could lug around a thousand-foot load. Ah well, we may

get credit for that one, too, from those not paying too much attention.

Vittorio and Francis decided that in addition to shooting some of the dance numbers and the odd production shot on various sets, the Steadicam could be used to the best advantage in the picture to photograph scenes in which Hank (Fred Forrest) and Franny (Teri Garr) were together, during which their relationship was usually either breaking up or breaking up again. These emotional conflicts needed to be covered closely, moving with their energy, flowing with as little interruption as possible, and since their arguments and reunions usually took place on the move up and down stairs and in and out of doors around their house, the Steadicam was highly useful. "Hank and Franny's house" was constructed intact within Stage 4, complete with forced perspective suburban street and miniature freeway in the background. Another of Dean's amazing sets, full of steps, doorways and other Steadicam-requiring stuff. I was dismayed to discover that when Vittorio rehearsed my shots with the little handheld video camera, he had been too cavalier about clearance in certain tight corners, and I sometimes had to fly the camera at high speed through places with less than an inch of room on either side!

This was also the home of The Elevator. A number of shots involved entrances and moves from room to room, followed by trips up and down stairs. My assistant and I would jump on the elevator platform, and since it moved with agonizing slowness, we would usually be only halfway up as Fred or Teri neared the top of the stairs. I would boom up to the highest extent of the arm, climb up on an apple box on the platform, and still have to step up as much as two feet to the hallway floor in order to catch up before whomever I was shooting disappeared around a corner into the bedroom or bathroom to continue the scene. Francis must have been mostly unaware of all this from the van, and may have wondered what all the muffled curses and crashing sounds were on the track! Wild stuff.

The elevator also had loose scissor joints, so it tended to plunge wildly from side to side. It was a little like riding a camel in the basket of a balloon! As the mechanism got progressively more tired, it acquired the habit of sticking to the floor in the low position and then suddenly releasing like a catapult. This frequently used up all of the possible "spring" in the Steadicam arm and in my legs as well, and deposited my assistant on the rafters. On descending shots, it finally began to hang up at the top and then suddenly let go and fall like a shot as the hydraulic fluid (library paste, I suspect) decided to let go.

Ultimately the damn thing refused to go at all, and I had one of those rare opportunities to be spectacular. I had had a premonition about all this and had asked our key grip, Bob Moore, to construct portable stairs with a ridiculously steep rise just in case; so when the elevator died, we brought in these steps which just fit into the opening. Now Jamie Anderson, with his focus box, had to get to the stairs first, climb up ahead and hide as I bounded up in time to meet Hank at the top of the real staircase. Both

Fred and Teri were tremendously helpful in adjusting the speed of their business on the stairs until this lumbering sideshow could hoist itself to the summit. I felt like planting a flag up there with each successful take.

Otherwise, we had a great time in the house set. One shot, which may or may not be in the picture now, involved a careful progression of moments during Hank and Franny's final reconciliation, culminating in my quiet withdrawal from the house, pulling back to get on the crane and boom up and ride back to the farthest extent of the stage, to hold for three minutes of possible credits as the sun came up (or down, or both!) and our collection of indolent pigeons was released, only to flap in circles down to earth and impersonate rocks. What a business!

The dance numbers on the Las Vegas street and on the Bora Bora set were exciting stuff for the Steadicam. High-speed choreography between dancers and camera, shots that went on for three or four minutes almost to the limits of endurance of cameraman, if not players Teri and Raul Julia (Ray). Wonderful stuff. We had to precisely hit dozens of marks, avoid shooting off the set, and manage one or two trips onto the crane for the high angles. Vittorio was a whirling dervish in orbit around the camera to get us through all this for each take. The biggest hazard was carbon monoxide from all of the picture cars maneuvering in close quarters on the stage.

As I write this, I am not sure exactly what will end up in the final version. It must be clear by now that this is a tremendously flexible production, and for a while the cut was changing more rapidly than the eye could follow. The Steadicam is just one of numerous techniques used to make this very special movie, and it wasn't necessarily integral to the mood or to some particular point of view (as in *The Shining* or *Wolfen*). Some early scenes have been rewritten or have acquired cutaways and coverage not originally planned, but I hear lately that quite a few of the shots are in the picture. In any case, I am content that the Steadicam had a contribution to make to *One From the Heart,* and it is only the most devoted fan of the machine that will actually get up and leave the theater if they recognize that a dolly is in use! In spite of, or perhaps because of, some of the well-known financial cliffhangers during the production, the crew was great and the spirit was great, and one actually had a feeling for the possibilities of the studio system at its best, during the best of times, on *One From the Heart.*

*(Garrett Brown and Cinema Products Corporation shared an Oscar in 1978 for the invention and development of the Steadicam. Brown has operated on numerous films and continues to work on the advancement of this technology. He also teaches Steadicam workshops.)*

First published in *American Cinematographer,* January 1982.

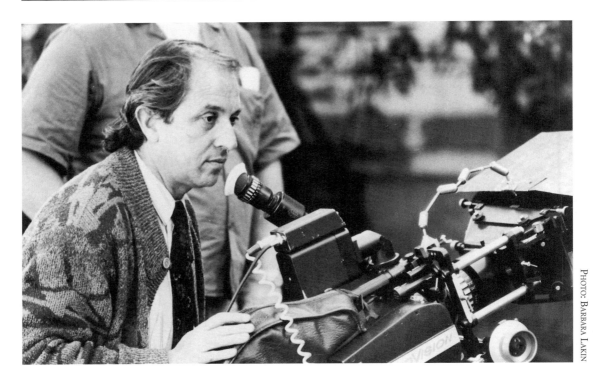

Storaro behind the Technovision camera.

# 5

## *Life Without Zoe*

by

### David Heuring and Nora Lee

Francis Ford Coppola's semi-autobiographical short, entitled *Life Without Zoe*, makes up one third of *New York Stories*. The enigmatic Vittorio Storaro once again joined Coppola as director of photography, reprising their collaborations on *Apocalypse Now, One From the Heart, Captain Eo* and *Tucker*. Other credits include *Last Tango in Paris, Ishtar* and *Ladyhawke*. Storaro's Academy recognition includes cinematography Oscars for *Apocalypse Now* (1979), *Reds* (1982) and *The Last Emperor* (1988), and he received a 1986 Emmy nomination for *Peter the Great*.

The story concerns an 11-year-old girl and her struggle to find balance and identity for herself and her family. An only child, Zoe lives alone in a posh Central Park hotel, alienated from her parents as a result of their constant traveling and occasional disagreements. According to Storaro, the artist mother and musician father represent two different points of view, the male and female components at war within the daughter. In a recent interview, Storaro expounded on his conceptual ideas for the film and his passionate opinions concerning cinematography in general.

"For *Life Without Zoe*, I was trying to represent the opposing forces in the family through the symbolic use of the sun, representing the father, and moon, the mother. For many reasons, the child has been trying to live in the world of her father. She is trying to be something which she is not, something that is only a part of her. When she finally understands that she is incomplete, she starts to move towards a balance between the two main figures in her life, the father and the mother. This was my guiding principle for shooting the film — to move with the story from an unbalanced situation towards reconciliation.

"The story starts in complete blackness, almost in the unconscious. From the blackness, we start to reveal the image of the little girl, and slowly she becomes whole. Step by step, we enter normal reality. From this moon setting, slowly everything changes and becomes the rising sun. We follow one beam of dawn sunlight, seeing the

entire city wake up. The beam reaches the hotel, following the lives of anonymous people in the hotel, until finally we arrive in the girl's bedroom, where she begins her day. This is how the film begins."

A similarly symbolic shot closes the film. Throughout the story, Zoe's search for balance and harmony brings her family together. After the reconciliation, however, the father must leave to perform, splitting the family again. This time the mother and daughter travel to join the father, setting up a spectacular final shot. Storaro explains: "We ended the movie in Athens, on the Parthenon, with a shot of the father playing the flute. The camera dollies back and down to discover that he is playing with a 100 piece orchestra in front of the Parthenon. We continue pulling back to view the Acropolis gate. It's a very magical moment, with the sun setting and the moon rising, and it is with this balanced moment that we end the movie. The Acropolis is a very magical place, a place full of balance and beauty. It was the perfect place to link together earth and sky, sun and moon, to symbolize Zoe's inner harmony. The family is reunited, and the inference is that when one performs, that personal expression doesn't necessarily mean a split from one's family."

After a thorough examination of a story's conceptual basis, Storaro constructs a visual approach using his theory of color physiology, which is based on scientific studies of human reactions to various colors and wavelengths. Armed with this overall plan of attack and his years of technical experience, he shoots the film. Storaro is more than happy to discuss the broad artistic concepts which guided him through *Life Without Zoe*, but he declines to discuss the technological specifics of his work.

"Having the proper vision for each story that faces your life, this is what's really interesting," he says. "After that, finding the tools and technology is really a very simple continuation of the journey. The important thing is to understand the main concept of the film itself, and to contribute a part of yourself to that concept through the cinematography. To discuss specific scenic examples is a mistake in my opinion, because they only have meaning in the context of the rest of the film. These thoughts and ideas are better expressed as a part of an overall feeling with which you approach the film.

"Too often people get caught up in the technical end of things," he says. "So many young cinematographers ask me which film stock I use, which equipment, what stop I was working at, et cetera. I feel that they just want to know what someone else is using so they can use it. They are missing the point completely. This way there is no proper input of an individual personality. It took me many years to bring a creative balance to the technological lessons I learned in film school. The technology is only a part of photography, and it is not the most difficult part.

"There is another aspect of this problem, this purely technical rather than artistic approach to cinematography. Recently, so many pictures look exactly alike, mostly because of the advances in using available light, the very fast film and lenses, and the Steadicam. Many cinematographers today are just working as fast and as cheap as they can, trying to prove that they can do the job with the least amount of light. There is no proper input of an individual personality, and it is difficult to recognize specific creative and expressive ideas from one picture to another. To me, this is not true photography.

"No doubt the technology is necessary and important," continues Storaro. "You choose what is right for the specific picture, but the good director of photography has learned which choices to make - why this lens, how to get a certain effect, what result a certain stock will give you - and he can concern himself with more important questions. I chose my tools long ago, and I really haven't changed very much since that time. Once in a while a new technology is presented, and I do some more tests. Very rarely, however, do I change the lab, the timing, the camera, the film stock company. Stocks are always changing and evolving, but I usually wait a long time, until I know that any new element is exactly right, before I use a new stock. As far as technology goes, I try to reject the brush. I don't care which brush you give me to paint with, I care about what a film is trying to say, and I hope I can say the same thing with any brush."

Storaro's fruitful collaboration with Coppola began with a brief introduction in Paris, when Coppola visited Bernardo Bertolucci on the set of *Last Tango in Paris*. A second meeting came when Coppola was shooting *The Godfather Part II* in Rome. Later, after discussing the conceptual basis of *Apocalypse Now*, Storaro and Coppola gained a mutual understanding and began a lengthy working relationship. "Francis and I found that we were traveling in the same artistic direction," explains Storaro. "Working together on a series of films seems to be a more European way of doing things. I have basically the same crew that I had 30 movies ago; it's a kind of professional family. When you feel comfortable working together, and you don't have to explain everything from the beginning, it's natural to continue the journey. lt's a step forward.

"For *Life Without Zoe*, Francis came to me with the main concept already there. It's a simple, short story, and I tried to develop the concept in the portion that belongs to me, the photography. Sometimes, as in *Tucker*, the concept is much more complex and requires much more discussion. In this case, however, we just concentrated on the idea of the infant and the two main elements working towards balance."

In addition to being a director of photography, Storaro is a crusader. His concern for the art extends beyond the boundaries of the movie set and is revealed in his heartfelt opinions about the state of cinematography. "In my opinion, the most important

advice we can give to the aspiring cinematographer is to remember that the technology is only a means to an end. The technology is there to back up the artistry. Rather than doing gymnastics every morning so that he can make the biggest jump with the camera, the young cinematographer should do mental gymnastics, learning to think deep into the story and how it applies to life. School is very important, learning the technology in order to express yourself. But a writer is not a writer when he only knows how to operate the typewriter.

"Also, I think cinematographers need to learn to say no sometimes. Today, all young cinematographers want one thing: to shoot a feature. They take the first opportunity that comes along, regardless of what the project means to them, or where they are in their development. When I was an operator, I refused to be a director of photography for a long time, because I knew in my heart that I wasn't ready. I could do the calculations, but I needed more preparation and evolution before I was able to truly express myself. This is why I am adamant about how students of cinematography should be taught. In my nine years of studying photography, no one ever explained to me the most important concept: first understand what comes from inside you, then know what kinds of tools to use."

First published in *American Cinematographer,* March 1989.

PHOTO: ANGELO NOVI

The elder Konrad (Chris Isaak) and his son (Alex
Wiesendanger) share a moment  as the enlightened
Lama Norbu (Ying Ruocheng) and Champa (Jigme
Kunsang) observe in *Little Buddha*.

# 6

## *Large Format Expands Little Buddha*

Bertolucci and Storaro reunite on an epic film that combines 35mm anamorphic scenes with 65mm footage.

by

Bob Fisher

At a January 1994 presentation at the Academy of Motion Picture Arts and Sciences, the Technology Council of the Motion Picture Television Industry demonstrated to an audience of some 400 filmmakers and students the aesthetic and technical differences of six different film formats, including Super 16, 65mm, and the four most popular 35mm formats. The serminar was capped with a presentation by cinematographer Vittorio Storaro, ASC, AIC, who previewed two scenes from *Little Buddha*, a Bernardo Bertolucci film scheduled for early summer release by Miramax Films.

The first scene, shot in 35mm anamorphic format (2.4:1 aspect ratio) was an intimate, contemporary scene filmed in a church in Seattle, where a Buddhist holy man is introduced to a boy and his mother. The second scene, set in India some 2,500 years ago, depicted the young Buddha, Siddhartha Gautama of the Sakyas, skirting the ugliness of poor village life by traveling on a private road his wealthy father has built for him. Shot in 65mm (2.2:1 aspect ratio), the images in this second sequence were incredibly sharp, bringing out even the distant horizons which seemed many miles away. Pristine and devoid of grain, the colors lushly saturated, the spectacular visuals brought a hush over the audience.

After the two scenes were presented at the film seminar, Storaro told the audience that he believes the 65mm format will take filmmaking to a higher plane in the HDTV era. He also surprised everyone by announcing his intention to work on feature projects only in 65mm.

Storaro's extraordinary decision to combine formats in *Little Buddha* came about as he debated how to handle the two stories being told concurrently in the movie. The first depicts the life of the original Buddha, while the second explores the relationship between a contemporary Buddhist and a boy he suspects to be Buddha's second coming. Early in the film, the story of Buddha is interjected sparingly via flashbacks. However, the two stories soon parallel each other, and the visual contrast between the past and present is an important element of the film's pictorial grammar.

In a more traditional film, the flashback sequences would be dreamlike and somewhat softer and hazier than the contemporary content of the film. In the case of *Little Buddha*, however, Storaro felt it was important for the audience to see the scenes as being bigger than life. "When I explained my idea for shooting the flashback sequences in 65mm, Bernardo became very excited," Storaro says. "He immediately recognized how the contrast in the quality of images would become part of the story."

Based on a concept developed by Bertolucci and produced by Jeremy Thomas, *Little Buddha* is Storaro's third collaboration with the duo, following *The Last Emperor* and *The Sheltering Sky*. Bertolucci and Storaro have worked together for almost 30 years; their collaboration began when Storaro was a 23-year-old assistant cameraman just getting his career underway on the director's *Before the Revolution*. Storaro has also photographed Bertolucci's *The Conformist*, *Last Tango in Paris*, *1900* and *Luna*.

The plot of *Little Buddha* revolves around Lama Norbu, an aging holy man who believes that his master, Buddha, may have been reborn. While visiting with three possible candidates in Seattle, Nepal and India, Norbu tells the story of Buddha. The film's cast includes Keanu Reeves as Siddhartha; Chris Isaak, Bridget Fonda and Alex Wiesendanger as the Konrad family; and Ying Ruocheng and Jigme Kunsang as, respectively, Lama Norbu and his aid Champa.

"It's a story within a story," Storaro explains. "When Norbu talks about Buddha, it is as if he is opening a beautifully illustrated storybook. We wanted it to be a perfect world seen through the eyes of a child."

Storaro, Bertolucci and costume/ production designer James Acheson discussed a visual frame of reference inspired by highly detailed and colorful 19th century miniature paintings by Indian artists, depicting the life of Buddha. But the decision to shoot the Buddha sequences, which make up about one-third of the 139-minute film, in 65mm wasn't made until live-action photography was underway in Kathmandu in Nepal. Storaro explains, "One evening very early in production, we were looking at dailies, and they were really quite good. When the lights came on, I asked Bernardo how we were going to photograph perfect images during the sequences depicting the life of Buddha."

Storaro, of course, already had a solution in mind; he had previously tried to persuade Warren Beatty to film *Dick Tracy* in 65mm. "I was convinced that [*Dick Tracy*]

deserved a bigger canvas to express all of the tonal and figurative nuances, and all of the subtleties of character," he says.

Storaro shot a number of tests with the new Arri 765 camera before Beatty decided to film *Dick Tracy* in 35mm anamorphic format. But the cinematographer, who had shot the 3-D special venue feature *Captain Eo* in 65mm, was convinced that many of the old concerns about shooting in 65mm were no longer relevant.

Bertolucci and Storaro had for many years talked about producing an epic film about the life of Buddha and had always assumed it would be filmed in 65mm, but their original project was shelved when financial backing fell through. Bertolucci decided to follow a different path with *Little Buddha*, a contemporary story focusing on the relationship between Lama Norbu, Jesse and his parents. However, Bertolucci and Thomas felt that shooting *Little Buddha* entirely in 65mm would be too costly and would make camera movement and lighting requirements too restrictive.

Storaro makes an eloquent plea for riding the 65mm format as a vehicle to the future of moviemaking, pointing out that at the beginning of the film industry, roughly 100 years ago, Louis and Auguste Lumiere and other industry pioneers never meant to restrict visual storytelling to a 35mm frame. The Lumieres experimented with 75mm film, and various other wide film formats also existed at the time; in 1899, Hopwood's Living Pictures catalog listed cameras and projectors that were available in nine different widths.

The 35mm format became a de facto standard around 1913, partially on the basis of a handshake agreement between George Eastman and Thomas Edison, who wanted to standardize production and distribution for economies of scale. There was a resurgence of wide film formats in Hollywood from the mid-1920s through the early 1930s, and virtually all of the studios had their own formats, ranging in gauge from 55mm to 70mm. Research and development slacked off during the Depression, but widescreen filmmaking came back in a big way in the 1950s in direct response to the erosion of box-office receipts because of the rising popularity of television. (Hollywood tried 3-D filmmaking first, but it proved to be a short-lived gimmick.)

The modern era of widescreen filmmaking began in 1952 with *This is Cinerama*. There was another flurry of specialized formats, which included CinemaScope, VistaVision, Todd-AO and Technirama. In 1956, Panavision developed Camera 65 for MGM; it was first used during the filming of *Raintree County*. Panavision soon contributed another key technical advance in developing spherical 65mm lenses, which eliminated the "fat faces" syndrome that had plagued earlier CinemaScope films.

Some 40 blockbuster or roadshow films, as they were called, were filmed in widescreen formats during this period, including *Oklahoma!, Around the World in 80*

*Days, The Sound of Music, Lawrence of Arabia, The Alamo, Exodus, My Fair Lady* and *South Pacific*. But wide film formats floundered due to the deadly combination of expense, unwieldy cameras, and slow film stocks and lenses; the curtain finally came down after the release of *Ryan's Daughter* in 1970. And after Panavision's Bob Gottshalk invented a set of 35mm anamorphic lenses which could be used in conjunction with much more mobile cameras to squeeze a widescreen image onto theatrical screens, film technology improved to the point where quality 70mm prints could be blown up from 35mm negatives.

During the late 1980s and early '90s, there were dramatic breakthroughs in 65mm camera and lens technologies, driven by the rising popularity of special-venue theaters at theme parks, world's fairs and expositions, and now hotels and shopping centers. One of the only theatrical features shot in 65mm format since *Ryan's Daughter* was Ron Howard's *Far and Away*, photographed by Mikael Salomon, ASC. There was much hope at the time that other widescreen films would follow in its wake, but *Far and Away* faltered at the box office. Nevertheless, Storaro believes that the return of 65mm is inevitable, and he intends to be in the front ranks of filmmakers working in the format.

On *Little Buddha*, Storaro ultimately convinced Bertolucci that the mobility of modern 65mm cameras, combined with advances in lens and film technology, would eliminate creative compromises in movement or lighting. He would shoot the 65mm scenes exactly the way he had planned to film them in anamorphic 35 format. In some ways, in fact, the format gave him even more more creative freedom.

"The 65mm lenses we used are spherical," he says. "There are limitations in rack focusing with an anamorphic lens, particularly on moving shots, and there is always some distortion." But the advantage Storaro most savored was the vast improvement in image quality. The image area on a 65mm frame is approximately six times larger, and the pictures aren't squeezed through the extra glass element present in anamorphic lenses.

"We are being honest with the audience when we tell them this is a 70mm film," he says. "We are fooling them when we make 70mm prints from 35mm anamorphic negatives. My heart was bleeding when I saw the intrusion of grain into 70mm prints of *The Last Emperor*."

Storaro still had to convince producer Thomas, who had questions about the higher cost of shooting so much of the film in 65mm, and who was also concerned about possible delays in the already hectic production schedule. Storaro assured him that no extra time, crew or equipment was necessary. The cinematographer notes, "People remember the stories they heard about the limitations in the 65mm format 20 years ago," when cameras were cumbersome and weighed hundreds of pounds,

lenses were bulky and slow, and color film speeds were limited to an exposure index of 100 in tungsten light. "Today, there are no such limitations. The Arri 765 cameras are somewhat larger than their 35mm counterparts, but they impose no limitations on movement."

As soon as Thomas concurred, Storaro made calls to Arriflex, Technicolor and Kodak. Despite the short notice, all three companies cooperated. Three Arri 765 cameras were shipped within days, along with a full complement of lenses in 40, 50, 60, 80, 100, 250 and 350mm focal lengths. Arriflex, which makes a policy of encouraging more 65mm production, also remounted Technovision lenses, which Storaro used to differentiate image quality in some scenes, for use with the 65mm cameras. The company also provided a number of other special devices, including adapting a Technovision matte box for use with the Arri 765s, and adapting the camera plate to fit the Vinten fluid head. In addition, two technicians (Manfred Jahn from ArriMunich, the rental company, and Arri Austria's Thomas Smidek, an expert in the electronic components of the 65mm cameras) were sent to the location to assist Storaro's crew on any technical issues.

Kodak, meanwhile, shipped an ample supply of Eastman EXR 5296 and 5293 film in 65mm format (the respective exposure indices are 500 and 200 in 3200 Kelvin tungsten light). Storaro notes that the availability of high-speed, low-grain films contributes significantly to the freedom of working in the 65mm format. Every visual detail is obvious to the audience when 70mm prints are projected on a large screen, allowing no margin for error, and the cinematographer must pull deep stops to maintain sharp depth of field.

T w e n t y years ago, proper exposure of 65mm film required approximately four times more light than 35mm, and this rough equation dictated much of the visual content of 65mm films made during that period. Today's films, says Storaro, "are so sensitive they are capable of registering all of the emotions and energy of everyone, including the actors, director and cinematographer. The 5293 film records less grain and a wide range of tonality, and it is fast enough for deep focuses. I used the 5296 film in situations where we needed even more sensitivity to light — for example, in the forest where Buddha was born."

The cooperation of the lab was another essential ingredient in the visual strategy. Negative from scenes filmed in Nepal was processed at Technicolor in Rome, while film from the Seattle location photography was processed at Technicolor in Los Angeles. Other work was processed in London, indicating a tremendous trust in the consistency of the processes at these different facilities. Storaro first used the ENR process (named for Ernesto N. Rico, a chemist in the Technicolor Rome lab) during the early 1980s on *Ladyhawke*. Technicolor Vice President Frank Ricotta describes it as a pro-

prietary process that leaves more of the silver in the print film when it is processed. This results in blacker blacks, heightens sharpness, and brings out more details in shadow areas without compromising the purity of whites or the vividness of colors.

Since the ENR process involves the print film rather than the negative or intermediates, it afforded Storaro the opportunity to orchestrate image quality, enabling him to fine-tune pictorial elements of the dailies and, ultimately, the release prints in his quest for the perfect image.

The Arri 765 cameras arrived in Kathmandu on schedule, but Storaro's crew still had only one evening to familiarize themselves with the new equipment. Other than the fact that the 765s are somewhat heavier and a bit more cumbersome than the Arri 535 cameras, most features are the same. When the team began using the 65mm cameras the next day, few people in the cast and crew were even aware of the transition.

"We didn't make any changes in lighting, camera movement or composition," says Storaro. "There were few limits imposed by the cameras. The crew easily lifted them on and off of dollies and cranes." The main concession was switching from Chapman PeeWee to sturdier Chapman Hybrid dollies to accommodate the heavier weight of the cameras. Everything else was the same, even the Vinten gearheads.

One of the significant challenges for Bertolucci and Storaro in translating the story of Buddha to film was finding ways to bridge the cultural gap between Eastern and Western audiences. Buddha is the spiritual leader of billions but remains an enigma to Westerners, who find it difficult to grasp the concept of someone who was neither saint, nor angel, nor god, but considered himself "the awakened one."

The story of Buddha, as related in the film, begins around the year 560 B.C. in northern India, where Siddhartha, the son of a powerful nobleman, is born. Seers predict that the infant Siddhartha will become either a general who conquers and unifies India, or a philosopher who becomes a spiritual leader of the world. His father is determined that Siddhartha will eventually follow in his footsteps as a ruler, and creates a sheltered environment for his son to deter him from following a spiritual path. However, his father ultimately fails to shield him from the uglier aspects of existence, and at the age of 29, after witnessing old age, pain, poverty and death for the first time, Siddhartha begins searching for the meaning of life.

He subsequently spends time with Hindu yogis and a band of ascetics, but neither group has the answer he seeks. Finally, Siddhartha decides that meditation is the path to enlightenment. He continues his wanderings for six more years until he comes upon the Bo (fig) tree, and vows not to leave that "immovable spot" until his meditation leads to enlightenment.

In a surreal visual-effects sequence, Mara, the lord of darkness, attempts to distract Siddhartha. He conjures up a violent storm, rains fireballs down on Siddhartha

and unleashes an army of flame-throwing archers upon him. Mara finally uses his own daughters in an attempt to seduce Siddhartha. Siddhartha emerges from this cosmic experience as the Buddha, and spends the next 45 years as a teacher and spiritual architect of one of the world's great religions.

The visual strategy devised by Storaro and Bertolucci divided *Little Buddha* into four elements, which are unified by the presence of Lama Norbu and three children. Each of the children is represented by a different color: red, green and blue. Storaro explains that these colors are psychological symbols for fire, water and air, respectively, which the ancient Greek philosophers defined as three of the four main elements of life. The fourth element is heart, which is represented by Lama Norbu. After these elements are combined and there is a balance, Storaro finally shows the audience the purity of white light.

Storaro believes that colors speak to the audience with silent words. "There is no doubt that every color is a specific wavelength of energy that can represent or symbolize a time or life or emotion," he says. At the core of his philosophy is his belief that "visually, movies are the resolution of a conflict between light and shadows. Light reveals truth and shadows obscure it, with a broad base of tonality in between."

In his command of filmmaking grammar, Storaro is inordinately eloquent. For example, in *Little Buddha*, he used older Technovision lenses in some scenes where he wanted a warmer look, almost plastic in texture. Storaro explains that newer lenses record sharper, colder and more defined images.

This kind of meticulous craftmanship has made Storaro a living cornerstone in the art of cinematography. He has won three Oscars (for *Apocalypse Now, Reds* and *The Last Emperor*), a feat that places him in an exclusive group with Freddie Young, BSC, Winton Hoch, ASC, Robert Surtees, ASC, and Arthur Miller, ASC. (Only Joe Ruttenberg, ASC and Leon Shamroy, ASC earned four Oscars.)

Each of these other cinematographers, however, compiled well over 100 feature credits while working under studio contracts. Storaro, still only 53, has some 40-plus feature credits, and tends to be both eclectic and selective in his choice of projects. His resume includes special venue projects (*Captain Eo*), TV miniseries (*Peter the Great*) and a recently completed 15-hour documentary on the history of Rome.

Storaro was born in that city in 1940, the son of a projectionist at Lux Films. He still has vivid memories of sitting by his father's side watching dailies day after day. "My father put the dream of working as a cinematographer into my heart," he says. Storaro was enrolled at the Duca D'Aosta technical photographic institute at the tender age of 11. He received a master of photography degree five years later. At that juncture, he began an apprenticeship at a photographic studio, and subsequently continued his education at the Centro Sperimentale di Cinematografia in 1960.

After working as an assistant cameraman for about a year, Storaro became an operator at the age of 21. In 1963, however, the Italian film industry ground to a halt. Literally no films were being made, and there were no jobs. Storaro used the time to augment his education. He spent two years studying the arts, including literature, movies, painting and sculpture. What he learned made a profound impact on his thinking about his art form, and on his understanding of the nature of light and color.

Storaro went back to work on *Before the Revolution*, which was his first contact with Bertolucci. He shot his first feature, *Giovinezza, Giovinezza,* in 1968. A year later, he worked with Bertolucci as a cinematographer for the first time on a film called *Strateglia del Ragno*. In 1970, the duo collaborated on *The Conformist*, which elevated both to international stature among their peers.

With *Little Buddha*, the pair continue what Storaro refers to as their "lifelong journey" together. "Someone asked me recently how long I prepared for shooting the story of Buddha," he offers. "I said 53 years — my entire life. You are influenced by everything, not just the films you shoot, but also by all of your other experiences. You can't make a film like this and not question your own life, your own impermanence, who you are, where you are going, and what enlightenment means to you.

"I woke up every day thinking I would take another step toward understanding the meaning of my life, and that was a wonderful experience. It's a journey you never complete. It is one thing to do research and to find a better way to record an image; that is something you do consciously. It is an entirely different experience when you discover something new at the moment of photography. Filming *Little Buddha* made me more conscious of that."

First published in *American Cinematographer,* May 1994.

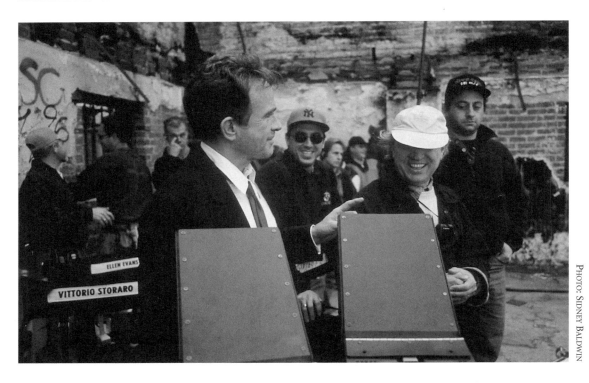

The Beatty/Storaro relationship, based on the duo's mutual respect and friendship, became a cornerstone of *Bulworth*.

# 7

# *Storaro and Bulworth*

The inventor of the Steadicam hits the campaign trail with director
Warren Beatty and cinematographer Vittorio Storaro, ASC, AIC.

by

Garrett Brown

The best fortune cookie I ever got said: "You have a unusual equipment for success."
True enough, and I'm most grateful — for my ticket into this business, and for the
the chance to interact with so many of its legendary practitioners. My most recent
excursion with the "equipment" was to Beverly Hills and South Central L.A. to work
with Warren Beatty and Vittorio Storaro on *Bulworth*, a risky, richly dark political
comedy about money, race and a U.S. senator who decides to quit lying and begin
rhyming. Co-written, produced, directed and acted by Warren and startlingly pho-
tographed by Vittorio (who served as a cinematographic Michelangelo to Beatty's rap-
spouting Pope Julius II), it will probably create quite a stir. Did I say risky? A lot of us
were out on the edge with this one, Warren most of all. At the end, I told him, "Being
Bulworth took some balls." He laughed.

## Being Vittorio

A three-time Oscar winner for his work on *Apocalypse Now, Reds* and *The Last
Emperor* (and a nominee for *Dick Tracy*), Vittorio Storaro is at the height of his pow-
ers - famous, successful and charismatic. So, more or less, are a handful of his peers,
but Vittorio is unique.

If you watch *Bulworth* in a perfect theater with wonderful projection and a pris-
tine ENR print, you will of course see what Vittorio has done; but even a googol of film
students sitting in the dark at the Googolplex with diagrams of lamp positions, dim-

mer settings and gels may not discover how he does it, or why, or with what joyous style. Storaro is renowned for his technical mastery, but his success goes beyond foot-candles and contrast ratios. I think it has to do with the distinctly unfashionable com-modity of character.

Warren compares making movies to repeated trips on a 747: "You can't get off in mid-flight, so when people ask each other back it means there is a shared feeling of confidence and understanding. Vittorio gets better and better. He always has the qual-ity of the picture as his first priority. He's in love with light, he's innovative, he has civil-ity and humor, and he's good for the mood!"

Storaro succeeds where perhaps some of his colleagues falter because of the way he conducts the core relationships at the heart of the business of cinematography. He works for a small number of difficult, world-class directors, always with a degree of mutual trust, respect and friendship that is gratifying to observe. I have known him since *Reds*, and if I could bottle his manner on the set — just his enthusiasm and his old-fashioned courtesy — I'd sell it at film schools, or slip it like a mickey into the occasional drink. It would improve working conditions industrywide.

Vittorio no longer refuses to do a picture if he can't bring along the Italian crew with whom he did 30 films. For *Bulworth*, he imported only Fabio Cafolla, the son of his former gaffer, to run the dimmer operation, and he says he is now eager to work with people of different nationalities and views. He has done at least two films each with Fabio, gaffer Gary Tandrow, first assistant Bill Clevenger, video technician Brad Ralston and myself, and he remains deluded that we are wonderful human beings. Gary says that Vittorio has been an inspiration to him: "Not only is he very spiritual in the way he lights and looks at things, but also in the way he treats peo-ple. Warren can be very taxing, but Vittorio knows him and sees the best in every-body and says that he is a genius."

Storaro is a good collaborator, which of course requires a point of view and a gift for resolving conceptual differences like an adult. Despite his considerable accent, as of *Reds* Vittorio was already quite eloquent in English. He is a highly civ-ilized character, and part of his effectiveness lies in the careful formality of his speech and writings, including his "ideations" — the extensive photographic con-cepts he devises for each of his films.

"We are introduced to the life of Senator Jay Bulworth in Washington, on a night filled with DARKNESS, interrupted by sudden FLASHES of LIGHT that attempt dramatically to illuminate his depression, that attempt to distance him from the sensation of life's deprivation that succeeds in enveloping him during this period of his existence. The BLACKNESS that surrounds him, the imminent ABSENCE OF COLOR around him, pushes him toward a determined, voluntary

desire for a SEPARATION of the two principal elements of which we are composed, and a movement into a conflict between life and death, between LIGHT and SHADOW …."

Storaro's serious conceptualizing and his lifetime of preparation for the job are the flesh and bones of his approach. In the 1960s and '70s he began to think about the symbolism of light and shadow in terms of conflicting energies — male and female, conscious and unconscious, natural and artificial. Ultimately, after *Apocalypse Now*, he stopped shooting for a year "in order to study and go deeper into the light — dividing the elements and discovering the world of color." The point is that his work has always been deliberate, based more upon thought and design than just the availability of ambient light, windows or practicals.

Vittorio speaks and writes of quasi-medieval "journeys" and "tasks," of baroque "dialogues of forces". His belief in the actual physiological power of color evokes Johann Wolfgang von Goethe's 1810 "Theory of Colors," which, though based on thoroughly discredited physics, has recently attracted attention because of new interest in the effects of color on behavior.

Vittorio's "ideation" continues, following *Bulworth* into a series of encounters that seem politically suicidal: "… illuminated by a series of colors: RED, color of emotion, of the beginning of life, of the birth of man; ORANGE, color of familial warmth, color of the passion for wellbeing; YELLOW, color of consciousness, of day, of the sun, of light … across the spectrum from shadow to light, to the equilibrium of WHITE …"

Storaro has acquired an encyclopedic knowledge of classical painting and sculpture, as well as a huge collection of art books. He prepares laser-printed books of scanned images — pictures and lithographs germinal to the visual scheme for each picture — but like his written manifestos, they are mostly for his own purposes. "It gives me from the beginning a very strong will, a very strong idea how I can do the movie. And not only how, but why … it becomes my own journey … not only visually, but personally … it becomes my joy and my suffering at the same time … I'm married to one major structure and once [the director and I] agree, it becomes my task. From that moment on, I'm ready to pay any price on any given day to achieve it. "

Warren said, "I appreciate the fact that he sets himself a skeletal goal … It gives a unity to his work, and he is never repetitious. I think it's good that people believe in things, and when they believe strongly in things I don't share, I don't scoff, any more than I'd scoff at my sister [actress Shirley MacLaine] and the things that she believes in." He told Vittorio, "Why not? If you love it, let's do it. I believe in you!"

"Everyone has his own language," says Vittorio. "This is mine. Warren needs different elements. Maybe we say the same thing."

## Technique

Storaro's technique is comprehensive and quite different from the usual practices in the United States He uses what he calls "puntiform" or pointsource lights and "multiform" broad sources, but seldom anything in between. He describes the former as "so tiny, or so far away, that it makes a strong separation between light and shadow, so no area is in penumbra." His broad-source lights consist of the same fixtures, but placed closer, and usually fronted with diffusion. "I was searching for a dialogue between two specific forces — one gives me very specific shadows and the other doesn't give any shadows at all." For what he calls "sculpting" with light, he rides these separate sources on the dimmer board.

On *Bulworth,* Storaro, used so-called "Jumbos" — large, multi-globe frames with 16 28-volt landing lights each — and a whole range of "Mini-jumbos" in diminishing sizes, as well as a series of "Tornado" lights using 120-volt Fay globes. They all run on 220 volts and are always prerigged to be dimmable with his small, state-of-the-art digital panels. "Jumbos" provide incredible punch outdoors. At great distances they become "puntiform" sources, except that, unlike conventional Fresnels, the arrays can be spread out horizontally. Vittorio's gaffer, Gary Tandrow, says, "They are only 10K each, but put out as much [light] as two or three Xenons. The bang for the buck is unbelievable."

All of his lighting instruments on the film were made by Filippo Cafolla, at Iride SRL in Rome, as were the original versions Vittorio ordered many years ago. Vittorio doesn't use HMIs and tries to avoid fluorescents - he doesn't like the color spectrum of either, and they aren't dimmable. He never erects forests of flags and nets and teasers. Tandrow says, "He will cut, and he likes large blacks and large silks, but if the light comes through the window, then he plays the whole scene around where that light comes from. He'll add a little fill, a little silver board to pick up the eyes. It's amazing, as if the world stood still when that perfect light came. And that's how he does the close-up, without relighting, unlike a lot of other cameramen who would turn off and start over. "

Storaro is a wizard with dimmers. He is one of the modern pioneers of the technique, beginning years ago with relayed instructions to his genny operator. Later he used individual electricians with radios and variacs, and on *One From the Heart,* a big analog dimmer board to control the fighting for my perambulating camera. The hardware has continued to improve, and Vittorio's mastery of it is impressive, particularly his placement of lights to accommodate successive close and wide shots, or actors moving within the set, or even the impromptu Steadicam reverse angle.

Vittorio currently uses a black-and-white monitor set up with great care to be, in effect, his contrast glass, so as he plays the dimmers he can judge the ratios from the screen. Incidentally, the preferred video tap on *Bulworth* was the CEI color tap because of its more accurate grayscale rendition in black-and-white.

The use of 220 volts for all lighting reduces the diameter of copper needed for the cable runs, and the dimmers yield a great saving of time and energy — fewer trips up ladders to throw in scrims, less heat on the set and longer life for globes and gels. Plus, everybody is visibly energized when the lights go up, and can relax when they go down. It's a great change from the timeless, perpetually lit studio sets that are so enervating after the 20th hour.

Is Vittorio fast? I think so. With the right pre-rig, the system can be very speedy. I asked if being fast was important to him. Vittorio said, "No. I understand that it can be very useful for the assistant director to know how long it will take if an actor needs to be called, or if they want to break for lunch — you have to tell them a number. But the process of changing from one shot to the other is very fast, so you can tell any number and everyone will be happy. Anyway, you will wait for the weather, for the director, for something. I don't care, if they tell me I'm the fastest or the slowest. Hollywood, to me, exaggerates everything."

Storaro's work ethic was the subject of much discussion. Key grip Bill Young observed that Vittorio was the hardest-working cameraman he had ever known. On scouts three months before shooting, Vittorio handed out diagrams marked with the location of lamps, generators and cable runs — not just for the location, but for each scene and every potential turnaround. In addition, the respective film stocks needed were listed in advance for the camera department.

Storaro's laboratory practices are scrutinized throughout the industry. Tandrow says, "On *Bulworth* he used the ENR process. It makes the blacks blacker, but it also desaturates color, which I didn't know until working on this film. So he overlights with color — he oversaturates. Rosco has made double CTOs and double CTBs, and they are working on a triple lavender that he particularly likes."

Storaro saturated the back wall of one office set with a remarkable deep green, to the extent that the mountainous black bodyguard and the flowered sofa on which he is seated become so camouflaged against the wallpaper that he rivets your eye when he moves — an amazing shot. I am convinced that Vittorio perceives the color spectrum with much greater intimacy than I do. Tandrow agrees: "He's the only cameraman I've ever worked with who can tell perfect greens and magentas. He can walk into a place and say exactly what it needs. We had to shoot under fluorescent conditions and match it, and he knew we needed more green. I couldn't see it with my eye."

Incidentally, Storaro says that *Bulworth* will be his last film shot for ENR. Kodak and Technicolor (which he humorously characterizes as his 'mother and father' in the creative world) both have technology in the pipeline that could make ENR unnecessary. Kodak is developing a new print stock with blacks that are said to be as rich as those in an ENR print. Technicolor, however, is reviving a version of the imbibition three-strip process, which provides ultimate color and contrast control and ensures longevity for the original prints. Vittorio told me happily that this new imbibition system may indeed be used for the U.S. release of *Bulworth*.

### "Photo-Graphy"

Movie stars, senators and popes (one of whom told me he had never even been inside a cineplex) have similar perks and powers. The Julius II/Michelangelo idea isn't entirely whimsical: as co-scenarist, producer, director and star, Warren Beatty has virtually total control of his world and a correspondingly acute need for the right kind of feedback and advice. But helping the pope is tricky — all of the constituencies normally served by a cameraman are here wrapped up in one individual. The Warren/Vittorio relationship was well-managed by both men, and it became a cornerstone of the movie. They have learned how to check and balance one another.

"After four pictures, you have a shorthand. I can say, 'Do you want to do that?' and it will be examined," said Warren. "Vittorio respects my seriousness in pursuing the theme of the movie. And if it's me, I'll see the flicker of an eyelash and know what he means. Vittorio will wait, and then he'll put it in the form of a question: 'Warren, do you think it might be possible that …'and I'll belligerently say, 'Why? What do you think?" and so on. What is absolutely spectacular about Vittorio is that he never loses interest in the process. He never phones it in. "

Warren Beatty is an actor's director — he sees the story from inside, from the character's point of view. Vittorio works from the outside in terms of script, direction, cinematography, production design. Warren distrusts big wide shots and angles that aren't "seen" through a character's eyes, and "interesting" shots that are more interesting than what is happening or what is said. Vittorio is interested in "what" happens on screen; Warren is more interested in "when."

Vittorio prepares a complete offering, beautifully lit, rehearsed, ready to roll. Warren says that he needs to shoot it from the other side. Vittorio's face lights up and he says, "Watch this!" and quickly turns it around. I asked him how he could do that and he said, "I like to light. "

He continued, "Don't get me wrong — sometimes I am very susceptible, in the sense that if Warren touches me in the principle, I am ready to leave… I am still very young and

can't completely control myself, but I trust Warren and I know that in the end, if the director is not convinced about my idea, I have to follow his. You stay with your principle and you defend it … but you shouldn't be its prisoner." (I have to say, I never actually saw Warren touch Vittorio's principle, but anything is possible in Hollywood.)

Warren insists on shooting the movie's first interior-to-exterior location scene in continuity, even though the light will certainly fade before the company can possibly make the move outdoors. Advice from cardinals, bishops and first A.D. Frank Capra III can't sway him. Vittorio says, "No problem."

"We went outside," reports Tandrow, "and he put up huge whites everywhere — silks and muslins — and bounced blue-corrected Jumbos and made it look like daytime, and it was pitch black!" This happened the evening that I arrived, and the speed and exuberance of it made me laugh.

My son Jonathan and I had a great time operating the picture, frequently with two Steadicams side by side (often at focal lengths that would frighten an astronomer!). Vittorio has perhaps the best compositional sense of anyone I know, and he manages to pass it along democratically. The three of us would sometimes be head to head, weighing up the framing elements on our respective monitors. Jonathan reports that when a giant abstract painting on set stubbornly reflected some lights, instead of losing the glass or changing its angle, Vittorio took black tape and added another big abstract shape that covered the reflection and maybe even improved the composition.

Storaro was always right in the thick of things, hands-on, cutting a path through the crowd or happily squashed into the back of the limo between Jonathan and Warren, improvising on his dimmer board with one hand and pulling focus with the other as our midnight convoy of vans and trucks swept up Olympic Boulevard, towing the shining black car on its long trailer, festooned with Mini-jumbos, glowing with Vittorio's long-ago-imagined coruscations of color.

The only time that we ever saw his spirit dimmed was toward the end of a run of very long days. "The thing that is crazy is to work more than the normal hours, because there is a moment when you start feeling that you don't love any longer what you're doing. I don't think I'll do another movie in Hollywood without being very specific — after the normal hour, I have to go home. Because my brain doesn't work any longer. Because my eyes are burning."

## Writing with Light

Storaro has often said, "Cinema is 'writing with light' [photo-graphy], in movement. He should probably add something about color, since he recently stated that he is no

longer interested in black-and-white cinematography. He jokes, "It would be like having a piano with only three keys. '

Incidentally, he is amazed and disturbed by the number of trucks required for American filmmaking, and he fears that our artistic reflexes are deadened when things are so bloated. It interests me that he will go out and do those $2 million pictures with Carlos Saura (such as *Taxi* and the still-unreleased *Tango*) simply because he loves to light. In addition to his best-known films, I admire his miniseries *Peter the Great* and Saura's recent quasi- documentary *Flamenco*. In every project he shoots, there are stunning images, and they stick with you for a long time.

Vittorio's work on *Bulworth* is amazing. I remember the rich chiaroscuro in the senator's office, and the L.A. City Hall (doubling for the Senate Office Building), with wonderful nighttime and daytime looks, and a great dimmer effect for summer lightning, flickering down corridors from all directions. I remember the light that fell everywhere on Halle Berry, as if Vittorio had suspended the laws of physics and poured it over her like champagne.

And about those colors, both subtle and in-your-face: maybe they really do mess with the mind. After all, there were fewer suicides once they painted the George Washington Bridge blue, and pink rooms are said to have a calming effect on violent mental patients, and Philly cop cars are less provoking in white than red ….

The united colors of *Bulworth* mark Vittorio Storaro's personal journey, as well as Jay Bulworth's last campaign: I remember RED in the church, and ORANGE in the mansion, the YELLOW of the ballroom and the odd GREEN cyclorama at the TV station. I remember the eerily VIOLET streets of South Central. And Fabio's great "Circolare" high on a crane, with its rings of aircraft landing lights focused together into an intense WHITE spotlight from above, scything across the last scene.

*Garrett Brown and Cinema Products Corporation shared an Oscar in 1978 for the invention and development of the Steadicam. Brown continues to operate on films and teach Steadicam workshops.*

First published in *American Cinematographer,* June 1998.

PHOTO: SIDNEY BALDWIN

Storaro adjusts dynamically changing lighting effects
on location for *Bulworth*.

# 8

# *Master of Light and Motion*

Vittorio Storaro, ASC, AIC answers *AC*'s questions about
his work on *Bulworth*.

Interview by

## Bob Fisher

If you knew you had no more than two days to live, how would you spend your time?
What would you do? What would you say? How would you change?

Such questions comprise the overarching theme of the 20th Century Fox film
*Bulworth*, which reunites cinematographer Vittorio Storaro, ASC, AIC and
director/star Warren Beatty for the fourth time. Both men earned Academy Awards in
1981 (Beatty for directing) for their collaboration on *Reds*, an epic story that chroni-
cled the role that American journalist John Reed played in the Russian Revolution. It
was a landmark film for Storaro, marking the first use of the ENR process developed
by Technicolor Labs.

In 1987, Beatty produced and starred in *Ishtar*, a comedy shot by Storaro. Three
years later, the actor/director and cinematographer teamed up again on *Dick Tracy* (see
*AC* Dec '90). Storaro mimicked a comic-book look on the big screen by visually punc-
tuating the images with deeply saturated primary colors, and earned his fourth Oscar
nomination. He received his first Oscar in 1979 for *Apocalypse Now*, directed by Francis
Ford Coppola, and his third in 1990 for *The Last Emperor*, a collaboration with
Bernardo Bertolucci. To put that achievement into perspective, no other living cine-
matographer has earned three Oscars, and in the history of the academy, only Joe
Ruttenberg, ASC and Leon Shamroy, ASC have received four statues.

Most of Storaro's early films were co-authored with Bertolucci, whom he met
while working as an assistant cameraman on *Revolution* during the dawn of both their
careers. They collaborated during the 1970s and '80s on such landmark films as *The*

*Conformist, Luna, 1900* and *Last Tango in Paris*, and reteamed in 1994 on *Little Buddha* (see *AC* May '94). Storaro's other notable narrative credits include *One From the Heart* (see *AC* Jan '82), *Ladyhawke, Tucker, Taxi* and the TV miniseries *Peter the Great*.

    *Bulworth* was written and coproduced by Beatty, who also directed the film and plays the lead role. The story opens in Washington, D.C., where Senator Jay Bulworth has decided to end his life. He has a wife and daughter, whom he wants to shield, so Bulworth hires a hit man to assassinate him. The contract requires satisfaction within two days, or the deal is off.

    Bulworth then flies to Los Angeles, where he goes through the motions of conducting a grueling campaign schedule. Freed from the burden of having to solicit money and seduce supporters, Bulworth does an extraordinary thing: he begins telling the truth. Step by step, Bulworth discovers that he has good reasons to stay alive.

    *Bulworth* was produced in Los Angeles on a relatively modest $30 million budget. Several scenes were filmed on stages, including the Washington, D.C. setting and the home of a campaign worker's grandmother. The rest of the movie was filmed at a variety of interior and exterior practical locations in and around Los Angeles, mainly at night. Following are excerpts from a conversation with Storaro about his approach to the picture.

*American Cinematographer*: **When did Warren Beatty first speak to you about** *Bulworth*?

**Vittorio Storaro:** The first time was in a telephone conversation. I was in Rome, and Warren called from Los Angeles. He said that I probably wouldn't want to shoot his new movie because it was going to be an ugly film. He told me the story and said he wanted the audience to follow the senator's journey during his final days as though they were watching it on C-Span [a cable channel whose content includes unedited and uninterrupted coverage of political events and activities].

**Do you recall your first reaction to that idea?**

**Storaro:** I had never watched C-Span, but I thought maybe Warren was planning to shoot this film using a Steadicam or a handheld camera once in a while, so the audience could see the images the way they would look if they were shot with a video camera for a TV screen. Warren sent me a copy of his script and two C-Span videotapes, one of the president and another of a governor. Then we spoke a second time.

**What did he say about working together during the second conversation?**

**Storaro:** He said that if we made the film together, he mustn't be Warren Beatty and I mustn't be Vittorio Storaro. We must turn a new page, because it was a time in both of our lives when we were ready to do something different and discover something new.

**How can you re-invent yourself and forget everything you have learned?**

**Storaro:** Naturally, you can't forget everything you know, but I approached *Bulworth* as though it was my first movie as a cinematographer. One of my first decisions was that I would ask [Steadicam inventor] Garrett Brown and his son, Jonathan, to operate on the picture. Garrett wasn't working on complete movies very often anymore, but I thought I could convince him to make this film. We shot around 90 percent of this movie with the Steadicam.

**Why was the Steadicam so important? Why not use dollies and cranes?**

**Storaro:** I explained that Warren wanted the audience to see large parts of this film as spectators watching the story on C-Span. We also wanted to create a feeling of a lot of energy and movement around the main character as his journey progresses.

**How much of *Bulworth* was filmed as planned and how much was improvised?**

**Storaro:** I had a clear idea of the structure after I read the script and spoke with Warren. I saw it as a journey that begins with Bulworth in a very deep, dark place in his life. He is so depressed that there is no opportunity to express emotions. In the first scene, everything is black. But the moment he starts telling the truth, he begins a journey toward becoming a more balanced person. I felt we could use the colors of the spectrum to represent the different stages of this journey. You always change little things while you are shooting or after seeing dailies, but *Bulworth* is the film we planned to make.

**Is the use of various colors symbolic, and if so, are there universal meanings?**

**Storaro:** Color is part of the language we speak with film. We use colors to articulate different feelings and moods. It is just like using light and darkness to symbolize the conflict between life and death. I believe the meanings of different colors are universal, but people in different cultures can interpret them in different ways. In the opening scene, the camera is motionless and there is an absence of color, which is black. During Bulworth's first campaign stop in Los Angeles, he visits a church in a black

community, where the main color in costumes and props is red, a symbol of birth and life. From the church, he goes to a meeting with some Hollywood film producers in a private home. It is a rich setting where he raises money. Orange symbolizes that feeling of comfort. When he visits an after-hours club, we used yellow, cyan and magenta, the opposites of the three primary colors [red, green and blue] that symbolize daylight. In this scene, Bulworth is considering his subconscious feelings.

The next day, he goes to the Beverly Wilshire Hotel, where he tells people in his own party what he is thinking. It is the first time he speaks honestly about his feelings in front of the members of his party; they don't expect a politician to tell them exactly what he is thinking. The color yellow symbolizes that he consciously knows what he was doing. During a television debate, we used green to signify knowledge, because it is the first time he reveals his feeling in public. Later, one of his campaign workers brings him to her grandmother's house, where he feels safe, believing that the assassin would not find him there. We used blue to signify freedom. Next, he meets a drug dealer, who explains why he uses children to sell drugs. Indigo symbolizes material power. We don't use white in this film until he completes his journey and is a whole person.

**How do you deal with the fact that people living in countries with different cultures might interpret the same colors in different ways?**

**Storaro:** Each color has a specific wavelength of energy, which we perceive the same way that we feel vibrations. Even if they aren't consciously aware of it, the audience can feel a difference between high and low wavelengths of energy. They are reacting to that feeling in addition to what they see on the screen.

**How did you and Beatty decide upon a 1.85:1 aspect ratio for *Bulworth*?**

Storaro: It was the right canvas for telling this story. I also used the older Technovision lenses and shot 99 percent of Bulworth with the Eastman [EXR] 5293 film because it is clear and sharp with no noticeable grain. Those decisions were based on the story and the mood we wanted to create. After this film, I shot *Tango* in Univisium format [2:1], using the newer Technovision lenses and a combination of 5293 and Kodak Vision 500 film.

**How would you characterize this picture — as a drama, comedy or something else?**

**Storaro:** It is a romantic film, a search for truth, and it is also a drama, since the assassin can appear at any time. Bulworth decides that he wants to live, but the man he paid

*Little Buddha*: Siddhartha reposes near a reflecting pool under the watchful gaze of young Jesse.

PHOTO: ANGELO NOVI

*Little Buddha:* Having taken full advantage of a magnificent structure, Storaro adds the final touch: a brooding sky.

*Little Buddha:* Storaro's lighting is combined with geometrical set design to create an otherworldly ambience.

*Little Buddha*: The colorful pageantry lavished upon
Siddhartha (Keanu Reeves) is presented in 65mm.

PHOTO: ANGELO NOVI

*Little Buddha*: A remarkable low-angle shot emphasizes unique Tibetan horns.

*Storaro: Writer of Light*

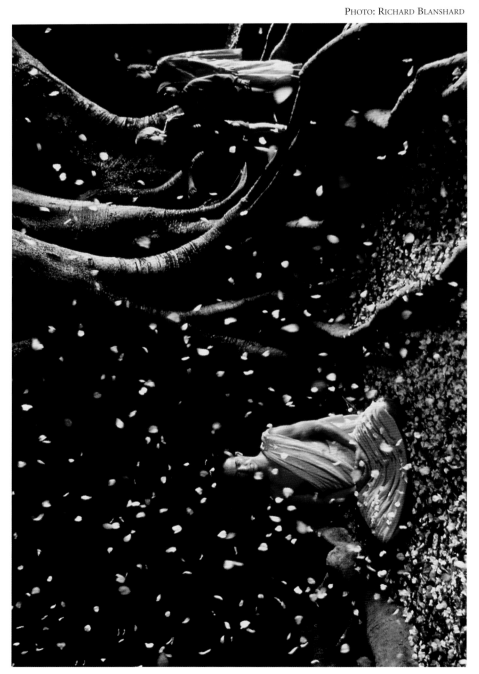

*Little Buddha*: Siddhartha meditates through different seasons.

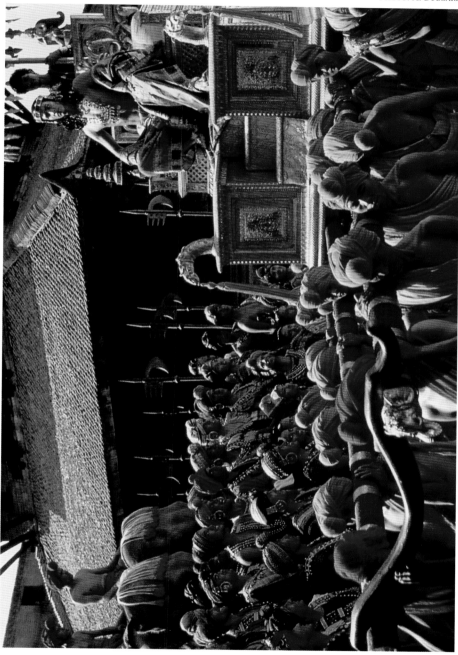

*Little Buddha:* The mighty Prince Siddhartha is borne along by his subjects.

PHOTO: ANGELO NOVI

*Little Buddha:* The three potential reincarnated masters are honored.

*Bulworth*: Storaro (and the larger-than-life Warren Beatty)
works the room at a political rally set in the Beverly Wilshire Hotel.

*Bulworth*: Amid Storaro's hypnotically rising and falling slashes of yellow and violet, Senator Bulworth learns to "get down" with Nina after hours at Frankie's.

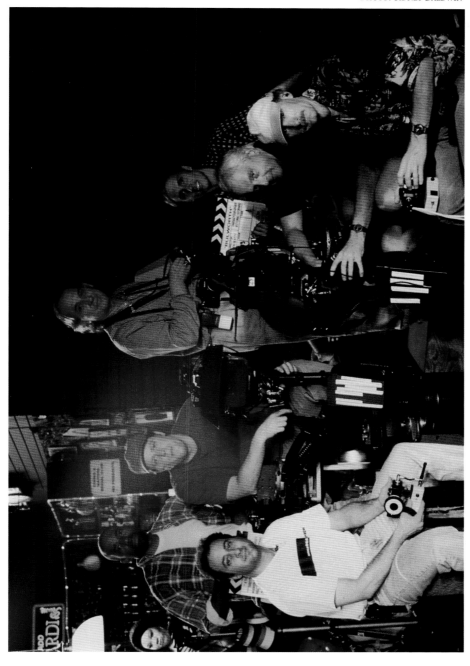

The camera crew on *Bulworth* (left to right): 1st assistant Art Martin, 2nd assistant Kirby Washington, Jonathan Brown, Storaro, 2nd Karl Linde, Garrett Brown and 1st Bill Clevenger

PHOTO: SIDNEY BALDWIN

*Bulworth:* Storaro balances deeply saturated yellow, violet and red filtration(opposite) for successive moments at Frankie's.

*Bulworth*: Storaro checks his meter while setting up a scene at Frankie's.

*Bulworth*: Another view of Storaro's color scheme at the nightclub.

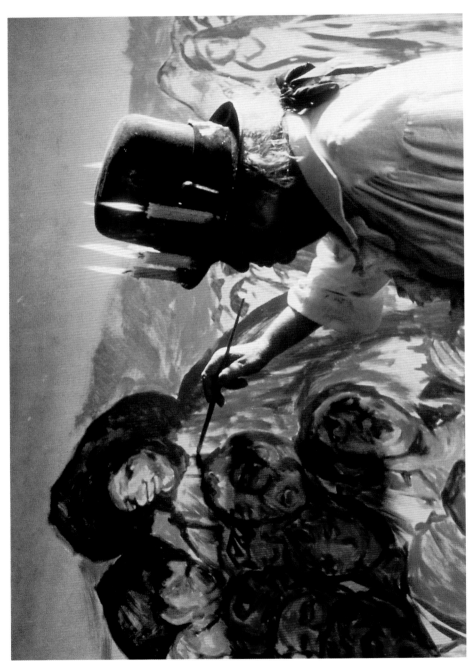

*Goya in Bordeaux:* An aging Goya (Francisco Rabal) paints with some unique lighting of his own.

*Goya in Bordeaux*: Goya dreams of his younger days as his many loves are assembled in an idyllic scene.

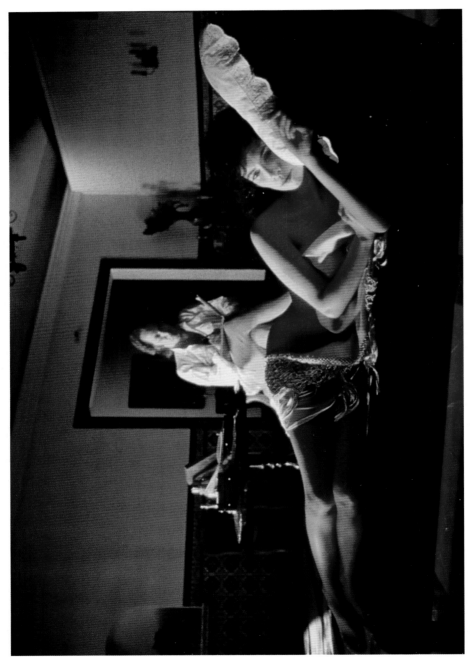

*Goya in Bordeaux*: Jose Coronado as the youthful Goya as a young man paints his mistress, the Duchess of Alba (Mariel Verdu).

to hire the assassin dies, so that suspense is there. Warren wanted his character to appear to be totally unpredictable. He also wanted the images to be realistic and believable, so the audience would feel as if they were watching the story happen on television. You want them to believe that what they are seeing is really happening, but of course, nothing is realistic in a movie since you select the angle, lenses and lighting.

**You said this movie has to feel believable and realistic. How did that jibe with the symbolic use of colors?**

**Storaro:** In a movie like *Dick Tracy*, you have permission to use unnatural colors because it is a fantasy. In *Bulworth*, there is a balance between believability and some very surrealistic visual elements that are justified by the story. [Production designer] Dean Tavoularis, [costume designer] Milena Canonero and I have worked together on different films, so it was an easy collaboration. We discussed these issues, and they built believable color elements into the sets and costumes.

**How did you handle lighting in situations where the camera was constantly moving?**

**Storaro:** I have been controlling light with a dimmer board since 1982, when I shot *One From the Heart* with Francis [Coppola]. It provides an incredible opportunity for the actors and cameras to move freely, and it allows me to express myself without restraints. I used an AC generator for the first time [in 1986] when I shot *Peter the Great* in Russia. It is much more reliable, and the cables are less [cumbersome].

During planning for *Bulworth*, we scouted locations and usually had the art department make sketches for the riggers. At that stage of the production, you have to anticipate where the actor might make spontaneous moves, or the director might change a direction. If you anticipate the possibilities, you can change the light [interactively] during a shot.

**Is the main advantage of using dimmer controls an ability to do more complex lighting as the actors move through a set during sophisticated moving shots?**

**Storaro:** You can do whatever you can imagine. In *The Last Emperor,* there is a long, dramatic scene in a conference room. The actors are seated around a table, and no one is moving. We used the dimmer to create the impression that time was passing and the sun outside of a window was setting. The dimmer board can also save time between setups. The gaffer, control board operator and I would arrive, and everything would be ready for us. The early dimmer consoles were made for

the live theater and television. We designed a new dimmer board for *Tango*. DeSisti Lighting [in Italy] made it for our use.

**Is it easier doing your fourth film with a director than the first one?**

**Storaro:** It is like we are making one, long movie together, and each time we add some new things to our vocabulary. Warren knows how I think, and I understand him.

**Isn't it very difficult working with an actor who is also directing the film? That must be particularly true on this picture, since Warren is in almost every scene.**

**Storaro:** Warren was doing four jobs on *Bulworth*, and that required incredible energy. One advantage today is that we have the video tap, so he can judge his performance on the monitor. Yes, it is difficult, but this film involved so much of Warren's personal vision that I don't see how another director or another actor could have seen and done things exactly the way he did.

**Did you use any diffusion or filtration?**

**Storaro:** No, absolutely not. Warren and I discussed this, and we agreed that it was important for the audience to see [Bulworth] as he is, without creating a sense that he is hiding behind something at this moment of his life. The viewers shouldn't see him as Warren Beatty.

**Did you use the ENR process during the making of prints?**

**Storaro:** I have used ENR for every movie I have made since *Reds*. It allows you to retain more of the silver in the print film, which gives you deeper, more saturated blacks. It is an alternative to making Technicolor release prints. I am hoping that the lab is ready to use the imbibition system for making Technicolor release prints in the United States when *Bulworth* is released. Once you have the choice of making true Technicolor release prints, I think there will be no reason for using ENR.

**Why do you prefer the title of "cinematographer" to "director of photography" in the credits?**

**Storaro:** Because we aren't directing. That is Warren's job. We are writing with light and motion to tell a story. That distinction is very important.

**Have you ever been tempted to direct?**

**Storaro:** People have asked if I was interested in directing since *The Conformist*. My answer is always the same. Thank you very much, but I don't have a need for the power that a director has. I like being a cinematographer; my total instincts, my knowledge and everything I have learned [is combined]. My wish for myself is that step by step, I am learning more about one specific area of creativity — writing with light and motion.

First published in *American Cinematographer,* June 1998.

PHOTO: MANUEL ZAMBRANA

The young Goya (Jose Coronado) walks through a gallery of his paintings
in *Goya in Bordeaux*.

# 9

## Screening Art

Storaro illuminates Goya.

**G**oya in Bordeaux is the fourth collaboration between three-time Oscar winner Vittorio Storaro ASC, AIC and director Carlos Saura, following *Flamenco, Taxi* and *Tango*. This time, the special demands of the musical, a genre which requires a perfect symbiosis between the light and colour of the photography and the directorial planning, have been exchanged for the challenge of approaching the work of a painter whose concept of light led to a new era in the history of art. Both Storaro and Saura see this project as an extension of their previous collaborations.

"Ninety percent of the shoot took place in the studio, where we reproduced streets, palaces and nightmares," says Storaro. "This was because a lot of the story happens inside Goya's head. But there are other parts where a sense of reality was important — for example, as when he speaks of his relationship with the Duchess of Alba, because this is a more complex part of the story. All of his creativity, his fantasy, his feelings and emotions are all there when he talks about her, and we needed truth and intensity."

*Goya in Bordeaux* brought together some of Spain's best acting talent, but also a major technical and artistic crew, the kind capable of mounting such a spectacular production. Along with Storaro, Saura united art director Pierre-Louis Thevenet and costume designer Pedro Moreno to bring alive his personal vision of Goya's world. He also took the risk of putting together a complex shoot, most of which took place on an enormous set with transparent sliding panels. Detailed planning and a complicated preproduction process meant that the shoot had to be completed in only nine weeks.

"In staging terms," notes Saura, "*Goya in Bordeaux* goes further down the line than *Tango*. Space and, above all, the light which makes up the space, are essential. The whole thing has been conceived as two large blocks: the acting and the lighting. The light is inseparable from our conception of the set. That's why Storaro was essential. He's a master of lighting, and here, on an extremely complex project, he's shown it once again."

With regard to the artistic direction, Storaro points out: "We were able to count on the valuable help of our art director Pierre-Louis Thevenet, who knows the period so well. We worked with new materials, with stamped plastic and projections, surfaces on which paintings or fragments of paintings are reproduced. The scenic space was like a huge game where the pieces were all mobile, so that at any point we could construct a bedroom, a drawing room, a corridor, or make a painting or engraving appear or disappear on the walls."

Thevenet has worked with filmmakers as varied as John Frankenheimer, Nicholas Ray, Pedro Almodovar, Francois Villers and Anthony Mann. "Carlos Saura has not simply made a historical film," he says. "As well as shooting the life of Goya, he has created a reflection of his painting. There are flashbacks of Goya's life in Spain, of the court… but only the props, the details of the set are real. When he does engravings, for example, it is specific and highly detailed, from the technical aspects of the press to the lithographs and the stone. Everything is exactly as it was during the period. Then again, the set did influence the themes, especially during Goya's visions. Or at the moment of the French occupation, when he remembers the bulls.…

"Working with a lighting maestro like Vittorio Storaro made this shoot a different experience. This was exciting work, far removed from normal set creation. We used montages, lighting effects and transparent panels. It was a whole different system. The three of us were in constant communication. Normally, the technician arrived on set after it had already been built, but this time we were practically working in the same department. If a decision had to be taken, the three of us met up — Carlos, Vittorio and myself. In some cases it took a week or two to create a set, because we had to experiment. The mise en scène came under constant scrutiny."

Another of the film's most visually spectacular moments — the staging of the dramatic Disasters of War — involves the popular Catalan action theater group La Fura dels Baus. La Fura has gained worldwide recognition with shows which included the staging of the opening and closing ceremonies of Barcelona's 1992 Olympic Games.

Jargen Miiller of La Fura explains: "We prepared a mise en scène based on the 17 engravings, which was shot as a single image. We've incorporated the elements of violence which are so dominant in Goya's work."

Costume designer Pedro Moreno explains what the production was all about: "There was a two-or three-month research stage. Then we started to create the characters. It is a story with a plot, as the director says, but it's not realism. I don't like working on realistic projects, because I don't believe that memory is ever the same as reality. We wanted to avoid betraying the spirit of Goya, but neither did we want to have clichèd, "Goya-esque" images. The film explores one of European history's most turbulent chapters."

"*Goya in Bordeaux* has been visualized as a journey through memory," observes Storaro. "The film begins in a bedroom, and the first time Goya is seen, he remembers his whole life. The scene is presented as an inner journey, which becomes a journey through the inner lives of ourselves — a journey through color to the conscious and unconscious minds. For a painter, as for a filmmaker, color is a very precise emotion which helps us to remember each moment of our lives. It's making a symbolic parallel between life and light. I try to tell Goya's life through his memories, and to explain through the use of color how it has influenced those memories."

Storaro first visited the Prado when he was in Madrid in 1960. "The Quinta del Sordo paintings were a revelation for me," he says, "a shock. Time passed, and during my first meeting with Saura, in Tokyo, when we were talking about doing *Flamenco*, we started to develop a point of view for the Goya project. Saura told me that his dream, which had been a constant inspiration to him throughout his career, was to make a film about Goya. That struck me, because I remembered that my first contact with Spanish culture had been through Goya and the poetry of Lorca.

"I now believe that we are extracting conclusions from what all the artists in the world have ever done, and not only film artists. I also mean painters, writers and musicians. For a cinematographer like me, painters are my direct inspiration. With *Flamenco*, we created a modem vision of the history of flamenco music in Spain. In *Taxi*, we took a trip around today's world, around the intolerance that exists everywhere. *Goya* is a journey around the history of the visual arts."

Storaro meters dynamic light falling on Josh Malina in *Bulworth*.

# 10

# *The Literature of Light*

An Interview with Vittorio Storaro ASC, AIC

by

# Ray Zone

On the evening of September 20, 2000, I enjoyed the unique opportunity to sit down with Vittorio Storaro, ASC, AIC in the clubhouse of the American Society of Cinematographers and discuss his work with him. Vittorio was in Los Angeles to complete color correction on the *Dune* miniseries, directed by John Harrison for the Sci-Fi channel of USA Networks. I found Vittorio to be very personable, perceptive and articulate about his philosophy of "writing with light," which is how he characterizes his work.

**Ray Zone: Welcome to Los Angeles, Vittorio.**

**Vittorio Storaro:** Thank you. Each time I come here, it's like returning home somehow. Basically, I really have two homes: Rome and Los Angeles. Wherever any project takes me, Prague, recently, for *Dune*, or Paris for *La Traviata*, or China for *The Last Emperor*, it seems that my family home is Rome and my professional home is really all around the world, particularly Los Angeles.

**I have some questions that will cover your career from the beginning up to the present.**

**Storaro:** I am very old (laughing).

**You're very wise in terms of cinema, particularly when it comes to light. You've accomplished a lot and you made an early start. You were a director of photography at a fairly young age.**

**Storaro:** First of all, I think we've got to do something to change this denomination of "director of photography." We're sitting in the house of the American Society of

Cinematographers. The Academy (of Motion Picture Arts and Sciences) recognizes our work as "achievement in cinematography." Photography is still just ONE single image. Cinematography contains movement. Not only different images, but a kind of SENTENCE. Cinematography is an art form because it is WRITING the story using the grammar of light, shadows and color — like a writer with words. But what the cinematographer does is to write the story with a beginning, an evolution and an end.

That's why I think we should go back to the original denomination of "cinematographer." Because there is only one director in cinema. Cinema is a common work; it's not just a single expression. Painting, photography, literature and sculpture are single expressions. Cinema is a common expression. It's taking many different personalities and bringing them together into what we call film. And because it's a common art, it needs absolutely one person who is leading everyone else in one direction. The main author is the director.

In my opinion, when the name was changed to "director of photography" from "cinematographer," there was some kind of complication with the director. We are like an orchestra with many different instruments. There is only one conductor who has to determine the overall context of the story, and that is the director. So we need to collaborate with our energies into the common art form with a single expression, single knowledge and emotion.

**In *The Bird With the Crystal Plumage* (1970) the scenes alternate from bright exteriors to dark interiors. It looked like you used a lot of practical light, perhaps because of budget limitations?**

**Storaro:** I believe that every film, with its own story, has its own style, which may have no relation to the budget. Sometimes, even with a limited budget, there is no limitation in terms of the possibilities. Those possibilities are connected with the story. You never feel that you have to give up on some kind of technical means in order to express yourself,because you select the technical in relation to the scene or to the style of the picture.

My choices with *The Bird With the Crystal Plumage* were connected to the style of the picture. During that period of my life, I was mainly investigating two opposing elements, good and evil, sun and moon, conscious and unconscious, with light and shadows. So in order to understand one or the other, and respect one or the other, I was making a separation between the two and using them as a confrontation to see what kind of story was coming out. Sometimes I was not using extra light, because to me it was wrong. I thought I only needed just one single light.

The day after *The Bird With the Crystal Plumage*, we started *The Conformist*. In *The Conformist*, we filmed the main character meeting his own teacher. I tried to show the principle the teacher was telling him about; it was the myth of the cave of Plato. In the myth, if you remember, there is a cave and there are people who are facing the interior wall of the cave. Behind them, in back of the cave, there is a fire. Between the fire and the people in the cave there are some people passing by with flags. They are projecting shadows against the back wall. The prisoners of this cave of Plato, watching these shadows, believe that this is reality because that's what they see from the beginning.

If you think, for a moment, this is a kind of metaphor for cinema. The prisoners of Plato are the audience. High above them is the projector. The people passing in front are the film. The back wall of the cave is the screen. Audiences today, watching film, are into these emotional abilities of the art. When Bertolucci told me the story of *The Conformist*, I knew that the concept for this film was so precise. I turned off all the other lights and used the only one that was outside the window, in order to have these perfect shadows of the character projecting into the room. And I used another window, when it was open, with natural light, to fill these shadows and let the shadows disappear. When the second window was closed, only one light was in this perfect relationship with him, reality, and its representation, his own shadow.

I used this as an example of how I was trying to tell that story. The point was to use only one specific light for that specific shadow. But particularly because of the period of Rome at that time, I was trying to be as claustrophobic as possible. The interiors were real location interiors but we decided that the characters should never see the real world outside. So we were either using a venetian blind or some kind of color on the windows so the actor would never connect with a real place, the real world outside the window, which was a world of fascism.

I was using this concept to have a very sharp light with very sharp shadows in order to show that there was no harmony, no union between these two worlds in the film, between the political moment in Italy and the personal moment. There was a kind of cage built of light and shadows around the protagonist, and it was almost monochromatic, not color, to show there was no emotion.

At that time, Paris was a place that every political person wanted to be to get away from fascism. Paris was the land of freedom, where anybody could say what they were thinking. So in the Paris section of the film, suddenly the color comes up. Everything becomes more colorful, particularly one color: blue. Blue, I didn't know at that time, mainly was an emotion for me. Later, I understood that it was a symbol of freedom.

In order to achieve that blue, I remember I told Bertolucci that I wanted to film at the "magic hour" with the light of dusk. You have this kind of feeling just before the darkness of night. We had to keep this magic light throughout the entire French

section of the picture. Bertolucci told me, "Vittorio, I like your concept, I like your idea, but we have to shoot from nine o'clock in the morning to seven o'clock in the evening. So do whatever you do, but I cannot stop the filming. I cannot wait for the magic hour."

In that case, I had to ask production to give me some money to buy gelatin to put in the windows. When the light wasn't at the magic hour, I used the gelatin. So I had to use more elements. Sometimes I use less. But what is really very important is the concept. The cinematography concept is the most important thing. Because at the end, what is really arriving at the audience is an image focused by light and all the components of light.

Everything is projected on the screen. It bounces back and lands on the human body. The human body doesn't see with only two eyes. It sees with the entire body. There is an energy that arrives at our body that gives a kind of an impression to which we will react emotionally. So what we receive from the screen is really the combination of all these energies. We are focused on the screen, and our metabolism changes from color to color.

In *The Conformist,* you see blue, and I'm sure that the audience is reacting in a specific way. And that's the most important thing. So in order to write with light and portray the story, you commit the story to an image on the screen. Those are the methods we're using. Of course, you have to be within the budget and the schedule of the film, but within this space we can use any of our tools, or elements that we know, in order to convey that emotion and those possibilities.

**You took a break at one time to do lighting for theater. You've said that it helped you to really understand cinematography.**

**Storaro:** Yes, I did that soon after *The Conformist* and before *Last Tango in Paris.* I did a project set in the 15th century based on a wonderful book called *Orlando Furioso.* I was always curious in going to the theater, particularly the opera, to see that every scene was opening with the light, and soon an actor or singer would come out. And very rarely did I see lighting that was helping the story or the drama.

In doing theater I realized that my desire was to show an audience the purity of light, the purity of the language of light. Most of the time when I was filming and putting together the light, I would see such beautiful tonality. Then, after that, these kinds of changes, how I could show emotionally these kinds of subtleties to an audience, would depend on the kind of lens, the kind of film, the kind of developing, the kind of printing, and the screening of the film.

While I was doing theater lighting, I realized I was missing something. I realized that my expression doesn't end by turning one light on or off, but in the way I catch this light. The difference can be between one lens or another, one film negative or another. What kind of developing do you use? Which kind of stock do you print on? What kind of special treatment can I do in the laboratory? So all of these are tools of the cinematographer. And I realized in that moment that they were part of my own expression. Our expression ends with the image on the screen.

**You've also referred to these tools as pen and brush to tell the story as a writer, a writer of light.**

**Storaro:** Yes, because I believe that we have a kind of grammar. Light has every possibility with its structure and modification from direct light, bounce light and diffusion light to all the different moments during the daytime with natural light, aurora, dawn, morning, day, afternoon, sunset, dusk. Each one has its own meaning. Each one has a specific emotion.

When we go into evening, we have different possibilities for the light. The moon is another source of light. And the sun, for centuries, has given to the human body a sense of physical action. When the sun is setting and the moon is rising, the body has a natural need for rest, a natural feeling of more sentiment and less action. The moon and its light are more connected to what is inside of us, the unconscious side, and not the outside.

This creates a balance in us. I think that if we lived 24 hours a day under the sunlight, in daytime, we would become crazy. What is really important for us is to search for and reach balance. To find equilibrium is a finale in life. In most of my work, I was just dealing, in an unconscious way, with emotion. Later, as I became more and more knowledgeable, I became more conscious of what I was doing. But basically, I was searching for equilibrium, to balance these two opposite forces.

**You used the painter Gauguin and his paintings as one of the main ideas for your filming of *Apocalypse Now*. How many of your films have been based upon the work of individual painters such as Gauguin?**

**Storaro:** Sometimes, even if you don't know something consciously, you still know it, because your eyes, since childhood, see books with paintingsp; you see paintings on walls, different ways of seeing. The culture is always around you. So you always have this kind of knowledge within yourself.

But yes, in every picture I relate to some kind of inspiration or connection. To be

more clear, I select one painter or one painting, and then I can easily put more information into my main concept.

In my first film, *Giovinezza, Giovinezza,* to make a visual metaphor I would say Caravaggio and Vermeer. In *The Conformist,* it was Magritte and De Chirico, DeChirico for the Roman part of the film and Magritte for the French part. In *Apocalypse Now,* there was a surrealistic way of seeing the jungle like Gauguin did, in a magical way. But there was another American artist named Burne Hogarth, who was drawing Tarzan a long time ago. I took this book to Francis Coppola and said, "Francis, look at this jungle. That's the way I would like to relate *Apocalypse Now.*"

There is no logical relation between *Heart of Darkness,* the novel by Joseph Conrad or the Vietnam War with Burne Hogarth. But now I had a kind of emotion to portray. Francis liked it and said, "Well, why not? Let's go for it." Also, in that period of my life I was searching for what is represented by light and by shadows. Natural energy vs. artificial energy is the main concept for me in *Apocalypse Now.*

Francis told me to read the Conrad novel and said, "There is a concept in there that maybe you'll like." And he was right. I read the book, and I found that I could write with light and color in telling this story. In the story, one culture was on top of another culture. There was a conflict between two different cultures. I said, "My God, I can portray this story using artificial light on top of natural light, artificial color against natural color." And that gave me the strength to feel that I could do something even in daytime, with the exteriors, with colored smoke, with filters. Colored smoke next to a rice field, for example. Or natural sunset light next to a huge generator with the arc light the American army was bringing to light the jungle at night. The jungle was conflict. So I was doing a color conflict to portray the conflict between the United States and Vietnam.

That's what I mean by writing the story with light. I was using the drama of light and color to visually show these opposing forces. *Apocalypse Now* was the most difficult picture I've ever done. It was the longest shoot. It was the most expensive one. It was the most far away one. It was the most dangerous one, and at the same time, the most emotional one. And probably the most beautiful one.

**What was the main idea or concept that you used for *Reds*?**

**Storaro:** *Reds* is the story of a writer, a journalist who is very connected to his own quality of reason. I took the visual of a plant or a tree. The story starts with the witnesses, and we did these parts against a black background. It was like those people were coming out from nothingness like roots, and telling the story. The story was very strong, and it told of a human being who was trying to use his own creativity to make literature. He was writing to tell about the human condition of the time. All the action

connected with his creativity was done in a monochromatic way, like through the trunk of his own life.

In every scene connected with Louise Bryant, his wife, the emotion was very strong; it was like a branch coming off the trunk with fruit and color. So the story was coming from the blackness of matter, with monochromatic tonality, to a branch with a different emotion, a different color. This was the relationship between John and Louise, a kind of graphic representation, let's say.

Sometimes I know very clearly that it is only theory. Of course, the audience doesn't need to know of the idea or the metaphor. But without those, the story would be left in a casual way. Even if the idea is totally abstract, I believe it is a very strong way to follow one specific path. In every single scene, with that concept, in a conscious way, the emotion will come back.

**In *The Last Emperor,* the opening with the present day is set in very flat, dull color, and that cuts back to the past, which is this rich yellow and red. How did you arrive at that?**

**Storaro:** Well, when I read the original book of the last emperor of China, I realized that it was a journey that he was doing within himself. He was forced to do that. Probably by himself, he was not willing to do that. When the Republic of China took him and put him in prison, it was like he was now writing his own story. In writing your story, you have to go back to every single moment in your life, every single emotion, every single age. And while you are writing, it is like you are finally realizing your life in additional levels of consciousness. In that moment, you see exactly what you are, who you are and what you've done. In other words, I was trying to make a parallel between life and light.

Life consists of several different ages from childhood to old age. Light is made with different colors: red, orange, yellow, green, blue, indigo and violet. So if I'm making a connection between these two, between life and light, I can portray every single memory.

For the first memory, I could portray red. When the protagonist cuts his own vein, we see red. Red is the first color in the color spectrum. It's a metaphor for birth. When the character sees the red, he remembers the first day, his birth as an emperor. This is a cut umbilical cord. He remembers the first day they knock on the door and say, "Come with us to the Forbidden City." They take him away from the mother. And I said to Bernardo, "Let's do this scene at night with torchlight, so I can do this red color." I wanted to get this feeling so I could make the connection between the vein and the blood of birth.

The second memory that he has, when he was five years old, I connected with the color orange. Orange is the color of the warm family, the feeling of the female, maternal embrace. His house at that time was the Forbidden City. It was all around him. So I connected this orange tonality around this section of his life to tell about the second step.

When he was crowned emperor, yellow was used to make a connection with the sun. Yellow is a color that represents the main forces on earth, the emperor. Yellow as the third color stands for what kind of person we are. It is the color of consciousness.

When the emperor has a tutor and starts to know what is going on in the world outside the Forbidden City, the world of reality, there is the color green. Green is the color of knowledge, the color when we learn about the world.

When he has been thrown out of the Forbidden City and he is in the English country garden, he feels free, like a playboy. Blue. Blue is the color of freedom. When he is called by the Japanese and asked if he wants to be an emperor once again, he says, "Yes, I would love to do that. I would love to play once again the part of the emperor," this time to do something with a will, not as a puppet. This is connected with the color of indigo, the color of wisdom, the age of 50. When he reflects on everything he did, his human actions to prevent killing, to call the blame on himself, he tells everybody what he thinks, and it is violet. Violet is the last color of human life. It is when we revert to somebody else.

At the end of the picture, he receives the diploma of a free man because he's been through all these stages of his own life. He understood his mistakes. He relives every different age, color and emotion. He receives the diploma on a day when there is a snow storm in wintertime. White.  White is the sum of every single emotion and age, every color that he's experienced in his life, to represent unity. It's an abstract concept.

And when I presented it to Bertolucci, he said, "I love the idea, but please come to China before you finish your concept because you need to know the Chinese way of living, the culture of China."

I said, "Yes, Bernardo." China helped me to write this story. Knowing the painting, knowing the literature, knowing the light helped me to capture China in different terms. This is an abstract concept, but it is so strong because it is telling the connection between light and life.

**How did you achieve those startling, saturated colors in *Dick Tracy*?**

**Storaro:** Well, once again, there is always one main idea. It has to lead you. When Warren Beatty gave me the script of *Dick Tracy*, I didn't know what to do. I grew up in Italy, and *Dick Tracy*, at least at my age, was not so popular like in America. And I told Warren, "I won't read this right away." I was just passing by Los Angeles on my way to

San Francisco to start on production of *Tucker* with Francis Coppola. When I am in production with a movie, I never read a script or story that is connected with another film because it would distract me.

Warren said, "That's okay, I'm not in a hurry. Don't worry." One day while we were shooting *Tucker* I was in a bar. There was a man with some newspapers and magazines from that period, 1935 to 1940, and I saw *Dick Tracy*. And I went over there and was looking at it, and I said, "Can I see it?"

And I realized that maybe I needed to do some research. I asked this man, "Can I buy this?" He said, "No. But I am the president of the Academy of Comic Strips and if you want to come to my house Sunday morning, we can talk. I have a huge collection, and I will see what I can do."

So I went over there with one of my camera operators and I looked at several different periods of *Dick Tracy* from the 1930s to the 1940s. They were always doing something different with color. I asked him, "Could I have one from each year, so I can see the different developments that he was doing with color?" He said, "I have to see if I have double copies, so I can give you the original. If I don't, I'll have to give you color copies." So he said, "Come back next week and I will give them to you. He gave me this large selection. And in looking at all these *Dick Tracy* strips, I realized that I already knew what he was doing. You know, unconsciously, you continue to work, whatever you are doing.

I finished work on *Tucker,* went back home and was looking through all my books. There was one idea I had that was connected with Otto Dix, and I realized that I had seen *Dick Tracy* before. It was inspired by the German expressionists, particularly post-expressionists like Otto Dix and George Grosz. "Oh my God," I said. I realized there is no doubt that at any time there is an art form that is going to influence any other art form and become the leader in that moment — painting in the Renaissance, architecture in the Roman time, music in the 17th century, literature in the 18th century, cinema in the present time.

After doing the research, I saw that cinema was incredibly influenced by German expressionism, as well as photography, music and comic strips. So I put together some research from books, and I saw that during German expressionism, they were mainly using primary color in conflict between one and another, never in harmony. There was, between the two world wars, a terrible period they had been through. So they were using color to visually tell the drama that they had experienced.

And I thought that *Dick Tracy* had to be done in this way. To show the conflict, we should use primary color in opposition.

**Those are probably the brightest primary colors in cinema.**

**Storaro:** The costume, production design and cinematography went in that direction to tell that kind of story. Being from Europe, I'm used to very subtle color, a calmer tonality. We think that culture is connected with subtlety. We're not that used to Pop Art.

**How did you find the challenge of lighting for 3-D with *Captain Eo*?**

**Storaro:** I was in Russia when Francis called me and said "We're doing this little movie that has to be done in 3-D for Disneyland, and maybe we can do it in a way that you can love 3-D. Usually 3-D is done to scare people." And he sent me this little story of this captain with his own creatures and his own code, let's say. He was travelling from planet to planet with his own energy, like music. He was bringing back those planets that had lost emotion, that had lost love. They were living in a kind of industrial world ,and he would bring them back to a more human way of living.

I realized I could portray *Captain Eo* as the sum of the entire crew. He was the leader. For every one of his creatures, I invented a different color, and he was the energy that connected it all together. The music that he was giving to people was not only music, but also energy that was visible. So we did it like that.

You know that each one of us has energy that comes out from our bodies. Any spiritual leader has even more energy in their hand. Kirlian photography can show us this energy. So the film used the concept that through energy, the world will change. And *Captain Eo* is giving back to these worlds their emotion.

There is a theory from Plato that states that not only do we have vision because we see, but also that the image goes into our eyes. It is the confrontation between these two energies that is making the image that is coming through our eyes. So the idea was to visually create this group of people, and the sound and music was using the energy to transform the world.

There is no doubt that 3-D can be the maximum chance that we have to visually represent everything we see, perspective that we would normally create in 2-D using light and shadows. And we were using the 65mm cameras that the Disney company put together. So we had real quality in production.

Now, step-by-step, we had a chance to put in the distance between the two eyes and make the subject far away or closer with the cameras. It gave us a chance to exaggerate the dimension. It is an incredible tool. Two 65mm cameras, one on top of the other, with one going through a split mirror, makes you lose a lot of light. Plus the Disney company told me, "Vittorio, because this is in 3-D, we need to shoot at f22. " They were budgeting to do just one shot a day, for the heat.

Also, they were planning to use a very low, sensitive film, so the grain wouldn't show.  I tested with a new film that was out at that moment and had a much higher

sensitivity. I knew there was more grain, but it was good enough, in my opinion, to save more than one stop of light. That helped a lot. Plus I thought that psychologically, we didn't need that grain, because in the cinema, an object comes very close to us and has to be sharp. But when we are watching something in real life, our attention is just on this subject, and we don't want to see sharpness in the depth of field. If we have both sharp, our brain is confused. So I think it is a mistake to have something very close in 3-D with the background also sharp.

With Francis Coppola and *One From the Heart* for the first time we were using the light board with the dimmer. With this we can control the light on the entire set with one single board. So I can take the light up and down depending on the angle of the camera or the shot, and within the same shot, in order to change the emotion in the scene. In *Captain Eo,* the dimmer board became really essential because I was able to keep all the lighting way down until Francis would say, "Roll camera." We were able to use a considerable amount of light. We were working at f8, I remember, and the set was not lit for the entire time. So we were able to shoot in a very comfortable way on *Captain Eo* without any major lighting problem.

**Your work with Carlos Saura is remarkable. From the early work with *Flamenco*, you used backlit screens, but in a very simple fashion compared to how you used them with *Goya in Bordeaux*.**

**Storaro:** Carlos Saura and I have done four movies together. We first met for *Flamenco*, and Carlos, who is a wonderful designer, told me, "Let's do *Flamenco* in a huge interior, but not using normal sets. I don't want to do *Flamenco* in a real location because it's too realistic. I just want to use screens on an aluminum frame with some kind of material we can move if we want and light, or use shadows, like a sculpture that we can walk inside of."

And I remember thinking about the light and story that the rhythm would tell. Because I need to have some kind journey to follow, I created on these different panels just movement of light and shadows. *Flamenco* is never performed during the day. They always start at the falling of the sun. So we used the screens to suggest sunset, going into the dark of evening, and the finish at dawn with the sunrise.

So the camera started with the sunset and ended with the sunrise. And we went through the entire cradle of night. Around these screens I was able to create just the conflict between light and shadow.

When we did another film, *Tango*, once again Carlos said, "I don't want to do *Tango* in a real location. I want to create our own world with the screens once again."

I said to Carlos, "Well, we have to do one step forward from what we did with *Flamenco*." So we were using the screens backwards, because *Tango* is the story of a

man, a film director, who is trying to tell the story of *Tango*, and at the same time it is the story of the country of Argentina. In doing this story, he is telling his own story. So I visualized the character going backwards, making a journey once again within the color spectrum. But this time it is back in time. So we were mainly using color against the screens.

The last scene is connected with immigration. Immigration in Argentina was mainly Italian and Spanish. I remember, in the airplane, going to Buenos Aires, and I was listening to classical music and reading the script. And while I was reading this scene, the music of Verdi came up. So I told Carlos that I had this incredible moment on the airplane, and I mentioned using this music to tell about the immigration. The Italians brought with them all their past history. He loved the idea but said, "What about the visuals, how do we tell the story visually?"

I said that for the Italian journey, we can symbolize the entire century with the circle of the sun and the moon in the same scene. So we had this huge backing and had two images, dawn and sunset. We can tell the entire journey of one day with the sun rising until the sunset. And we ended with a very strong, red-colored sunset, which is connected with the beginning of the director's journey.

At that time, I saw in Los Angeles, at Rosco a material that was double TransLite called Rosco Mural. You can print an image on both sides. So with my son Fabrizio, I started working on the computer to get different photographs of sky, a huge beautiful skylight. We did one with the color of the dawn. And we did another one for sunset. We had it printed it on a huge screen 30 feet by 400 feet. We used this huge TransLite but with the double image. With light on the front and the back, we were able to create this incredible journey of immigration through the entire day.

When we were working on *Goya in Bourdeaux*, Carlos told me that he didn't want to go on a real location. "Let's keep using our style, creating our environment through the screen," he said. "But what can we do? We've done light and shadows. We've done color." I said, "Now we need images." But how can we put images on them? So, working with Fabrizio, I asked the production designer for images. We were scanning, checking color and building in a different way, looking out the windows, out the doors. Everything was done with the production designer. And we were going to a plotter with a huge painter which is 5 meters wide. We printed this material with the colors of the sets. And using the lighting from the front to the back, according to the scene, we were able to create a real place or, in a fantastic way, go out of this place and visualize something else.

We used this same technique for Goya's paintings. We had every one of Goya's paintings and original big photos from the Prado. We scanned them. And my son and

I looked at books and went to the Prado to look at the original paintings. We were making corrections from the photos and books to the original paintings. They looked exactly like the original paintings, and we printed them on this translucent material to look like walls.

*Goya,* to me, represented a huge door opening on the visual world — a chance to bring images together using cinematography.

# *Vittorio Storaro*
# FILMOGRAPHY
## (Cinematographer)

**1. *Giovinezza, Giovinezza*** (1969)
…aka *Youthful, Youthful*

Directed by Franco Rossi
Written by Vittorio Bonicelli, Luigi Preti (novel),
Franco Rossi (also story)

CAST
Guido Alberti – Avv. Milazzo
Torello Angeli – Giancarlo Baldini
Olimpia Carlisi – Olimpia
Antonio Centa – Cavallari Giuseppe Faggioli
Piero Gerlini – Arlotti, il barbiere
Colomba Ghiglia – Laura Sandro Grinfan
Alessandro Haber – Guido Cohen
Roberto Lande – Giordano
Leonard Manzella – Efrem
Katia Moguy – Mariuccia
Alain Noury – Giulio Govoni
Marcello Portesi – Claudio Trionfi

Produced by Ugo Guerra, Elio Scardamaglia
Original music by Piero Piccioni
Cinematography by Vittorio Storaro
Film Editing by Giorgio Serrallonga
Production Design by Giancarlo Bartolini
Salimbeni
Costume Design by Giancarlo Bartolini Salimbeni
Makeup Department
Luciano Giustini – makeup artist
Maurizio Giustini – key makeup artist
Vittoria Silvi – hair stylist

**2. *Delitto al circolo del tennis*** (1969)
…aka *Crime at the Tennis Club*

Directed by Franco Rossetti,
Written by Ugo Guerra (also story), Alberto
Moravia (story), Franco Rossetti (story),
Francesco Scardamaglia (also story)

CAST
Anna Gaël – Benedetta Varzi
Roberto Bisacco – Sandro
Angela McDonald – Lilla Dossi
Cristea Avram – Riccardo Dossi
Mario Guizzardi – Richter

Produced by Ugo Guerra
Original music by Phil Chilton ,
Peter L. Smith
Cinematography by Vittorio Storaro
Film Editing by Alberto Gallitti
Production Design by Giuseppe Bassan, Dusan
Jericevic, Massimo Vigneti
Costume Design by Gaia Romanini
Makeup Duje Duplancic

**3. *Uccello dalle piume di cristallo, L'*** (1970)
… aka *Bird with the Crystal Plumage, The*
(1970)
… aka Bird with the Glass Feathers (1970)
… aka Gallery Murders, The (1970)
… aka Geheimnis der schwarzen Handschuhe,
Das (1970) (West Germany)
… aka *Phantom of Terror* (1970)
An American writer in Rome witnesses a murder attempt on a woman in an art gallery by a sinister man in a raincoat and black leather gloves. The writer gets trapped between a double set of glass doors in going to her aid. The woman survives, but

the police say that she is the first victim of a notorious serial killer to have survived. When the police fail to make any progress with the case, the writer decides to investigate on his own. He turns up several clues that point to a possible suspect. Does the writer know what he is doing?

Directed by Dario Argento
Written by Dario Argento

CAST
(in credits order)
Tony Musante—Sam Dalmas
Suzy Kendall – Julia
Enrico Maria Salerno – Morosini
Eva Renzi – Monica Ranieri Raf Valenti
Giuseppe Castellano – Agent
Omar Bonaro – Other agent
Werner Peters – Antique Dealer
Gianni De Benedetto – Professor Renaldi (as Gianni Di Benedetto)

Produced by Salvatore Argento, Artur Brauner
Original music by Ennio Morricone
Cinematography by Vittorio Storaro
Film Editing by Franco Fraticelli
Production Design by Dario Micheli
Costume Design by Dario Micheli
Makeup Department Giuseppe Ferranti….
Makeup artist Lidia Puglia

4. *Strategia del ragno, La* (1970)
   … aka *Spider's Stratagem, The* (1970)
   At the request of his dead father's mistress, Athos Magnani, a young researcher, returns to Tara, where his father was killed before Athos was born. The father is also named Athos Magnani and he looks exactly like his son. There is a statue of the senior Athos in the town square. Everyone in Tara says that Athos's father was killed by a fascist in 1936 . The son untangles a web of lies only to find that he himself is ensnared in the same web.

Directed by Bernardo Bertolucci
Written by Bernardo Bertolucci, Jorge Luis Borges,

Eduardo de Gregorio,
Marilù Parolini

CAST
Giulio Brogi – Athos Magnani, father and son
Alida Valli – Draifa
Pippo Campanini – Gaibazzi
Franco Giovanelli – Rasori
Tino Scotti – Costa
Allen Midgette – Sailor

Produced by Giovanni Bertolucci
Music by Arnold Schönberg, Giuseppe Verdi
Cinematography by Franco Di Giacomo, Vittorio Storaro
Film Editing by Roberto Perpignani
Production Design by Maria Paola Maino
Costume Design by Maria Paola Maino
Second Unit Director or Assistant Director Giuseppe Bertolucci
Other crew
Giuseppe Lanci – camera operator
Alfredo Marchetti – key grip
Enrico Umetelli – camera operator

5. *Conformista, Il* (1970)
   … aka *Conformist, The* (1970) (USA)
   … aka *Grose Irrtum, Der* (1970)
   (West Germany)
   A young man named Marcello has just taken a job working for Mussollini. It is 1938 in Rome. Marcello is courting a beautiful young woman who lures him to conform to fascism. Marcello's fascist superiors give him an assignment just as he is going to Paris on his honeymoon. He is to look up an old professor who fled Italy when the fascists came into power. As Marcello and his bride change trains at the border of Italy and France, his bosses give him a gun with a silencer. With a flashback to Marcello's childhood, the basis of his fascism and its connection to his sexual identity are exposed.

Directed by Bernardo Bertolucci
Written by Bernardo Bertolucci,

Alberto Moravia (novel)

CAST
Jean-Louis Trintignant – Marcello
Stefania Sandrelli – Giulia
Gastone Moschin – Manganiello
Enzo Tarascio – Professor Quadri
Fosco Giachetti – Il colonello
José Quaglio – Italo
Yvonne Sanson – Madre di Giulia
Milly – Madre di Marcello
Giuseppe Addobbati – Padre di Marcello
Christian Aligny – Raoul (as Christian Alegny)
Carlo Gaddi – Hired Killer
Umberto Silvestri – Hired Killer
Furio Pellerani – Hired Killer
Pasquale Fortunato – Marcello bambino
Dominique Sanda – Anna Quadri
Pierre Clémenti – Pasqualino Semirama
Pierangelo Civera – Franz
Alessandro Haber – Cieco ubriaco
Antonio Maestri – Confessore
Massimo Sarchielli – Cieco

Produced by Giovanni Bertolucci. Maurizio Lodi-Fe
Original music by Georges Delerue
Cinematography by Vittorio Storaro
Film Editing by Franco Arcalli
Production Design by Ferdinando Scarfiotti
Costume Design by Gitt Magrini
Makeup Department Franco Corridoni,
Rosa Luciani

**6. *Giornata nera per l'ariete*** (1971)
   … aka *Evil Fingers* (1971)
   … aka *Fifth Cord, The* (1971)
   Italian giallo, very typical of early 1970s, in which a heavy-drinking journalist tries to solve a series of murders with some common elements. A good twist is provided at the end, with the protagonist giving a voice-over summary. The murder scenes are given a silent treatment, which makes them even more unnerving.

Directed by Luigi Bazzoni
Written by Luigi Bazzoni, Mario di Nardo

CAST
Guido Alberti – Luciano Bartoli
Maurizio Bonuglia – Dr. Bini
Rossella Falk – Sophie Bini
Silvia Monti
Franco Nero – Andrea Bild
Wolfgang Preiss
Edmund Purdom – Edouard
Renato Romano – John Lubbock
Pamela Tiffin – Lu
Ira von Fürstenberg – Isabel
Produced by Manolo Bolognini
Original music by Ennio Morricone
Cinematography by Vittorio Storaro

**7. *Addio, fratello crudele*** (1971)
   … aka *'Tis a Pity She's a Whore* (1971) (USA)
   In a highly amoral atmosphere, a man lives in sin with his mistress. His daughter and his son fall in love, and have incestuous relations with the mistress even after she marries the father. The patriarch seeks revenge. All ends in tragedy. (Based on the play *Pity she's a whore,* with its Italian Renaissance setting and poetic text.)

Directed by Giuseppe Patroni-Griffi
Written by Carlo Carunchio, John Ford, Giuseppe Patroni-Griffi , Alfio Valdarnini

CAST
Charlotte Rampling – Annabella
Oliver Tobias – Giovanni
Fabio Testi – Soranzo
Antonio Falsi – Bonaventura
Rik Battaglia – The father
Angela Luce – The father's woman
Rino Imperio – Soranzo's manservant
Produced by Silvio Clementelli
Original music by Ennio Morricone
Cinematography by Vittorio Storaro
Film Editing by Franco Arcalli
Art Direction Mario Ceroli

Costume Design by Gabriella Pescucci
Makeup Department Mario Di Salvio, Mauro
Gavazzi

### 8. *Ultimo tango a Parigi* (1972)

… aka *Dernier Tango à Paris, Le* (1972)
(France)
… aka *Last Tango in Paris* (1972) (UK) (USA)
Jeanne, a beautiful young Parisienne, encounters Paul, a mysterious American expatriate while looking for an apartment. Paul is mourning his wife's recent suicide. Jeanne and Paul are instantly drawn to each other. They have a wildly passionate affair and yet do not reveal their names to each other. Paul struggles with his wife's death. Jeanne prepares to marry her fiancé, Tom, a film director who is making a cinéma-vérité documentary about her.

Directed by Bernardo Bertolucci
Written by Bernardo Bertolucci, Franco Arcalli,
Agnès Varda

CAST
Marlon Brando – Paul
Maria Schneider – Jeanne
Maria Michi – Rosa's Mother
Giovanna Galletti – Prostitute
Gitt Magrini – Jeanne's Mother
Catherine Allégret – Catherine
Luce Marquand – Olympia
Marie-Hélène Breillat – Monique
Catherine Breillat – Mouchette
Dan Diament – TV Sound Engineer
Catherine Sola – TV Script Girl
Mauro Marchetti – TV Cameraman
Jean-Pierre Léaud – Tom
Massimo Girotti – Marcel
Armand Ablanalp – Prostitute's Client
Jean-Marc Bory – (voice)
Rachel Kesterber – Christine
Veronica Lazar – Rosa
Darling Légitimus – Concierge
Ramón Mendizábal – Tango Orchestra Leader
Mimi Pinson – President of Tango Jury

Peter Schommer – TV Assistant Cameraman

Produced by Alberto Grimaldi
Original music by Gato Barbieri
Cinematography by Vittorio Storaro
Film Editing by Franco Arcalli
Production Design by Ferdinando Scarfiotti
Costume Design by Gitt Magrini

### 9. *Malizia* (1973)

… aka *Malice* (1973)
… aka *Malicious* (1973)
Angela, a beautiful maid, becomes the object of affection for a widower and his sons. Only one of them succeeds in capturing her love.

Directed by Salvatore Samperi
Writing credits Ottavio Jemma, Alessandro
Parenzo, Salvatore Samperi

CAST
Laura Antonelli – Angela
Turi Ferro – Ignazio
Alessandro Momo – Nino
Tina Aumont – Luciana
Lilla Brignone – Granma
Pino Caruso – Don Cirillo
Angela Luce – Widow Corallo
Stefano Amato – Porcello
Gianluigi Chirizzi – Nuccio
Grazia Di Marzà – Adelina
Massimiliano Filoni – Enzio

Original music by Fred Bongusto
Cinematography by Vittorio Storaro
Film Editing by Sergio Montanari
Production Design by Ezio Altieri
Costume Design by Ezio Altieri
Makeup Mauro Gavazzi

### 10. *Giordano Bruno* (1973)

Giordano Bruno was an Italian writer who incurred the wrath of the Vatican and was burned at the stake in Campo dei Fiori in Rome on 17

February 1600. A statue stands today in his honor at this piazza. As a young man, Bruno entered the Dominican Order. He was ordained in 1572, but very shortly was travelling through Europe, publishing original literary, theological and philosophical texts that upset the Catholic Church. In Venice in 1591, Bruno displeased a superior and was denounced in the Inquisition. He was sent to Rome to spend six years in prison before he was burned at the stake for heresy.

Directed by Giuliano Montaldo
Written by Lucio De Caro, Giuliano Montaldo

CAST
Gian Maria Volonté – Giordano Bruno
Charlotte Rampling – Fosca
Hans Christian Blech – Sartori
Mathieu Carrière – Orsini
Mark Burns (I) – Bellarmino
Massimo Foschi – Fra Celestino
Giuseppe Maffioli – Arsenalotto
Renato Scarpa – Fra Tragagliolo

Produced by Leonardo Pescarolo, Carlo Ponti
Original music by Ennio Morricone
Cinematography by Vittorio Storaro
Film Editing by Antonio Siciliano
Production Design by Sergio Canevari
Set Decoration Sergio Canevari
Costume Design by Enrico Sabbatini

## 11. *Driver's Seat, The* (1974)
   … aka *Identikit* (1974)
   … aka *Psychotic* (1974)
   A mentally ill spinster named Lise journeys from her home in Britain to Italy. She is on a strange journey to find love with any man who will agree to murder her.

Directed by Giuseppe Patroni-Griffi
Written by Raffaele La Capria, Giuseppe Patroni-Griffi, Muriel Spark (novel)

CAST
Elizabeth Taylor – Lise

Ian Bannen – Richard
Guido Mannari – Carlo
Mona Washbourne – Mrs. Fiedke
Maxence Mailfort – Bill
Andy Warhol –

Produced by Franco Rossellini
Original music by Franco Mannino
Cinematography by Vittorio Storaro
Art Direction Mario Ceroli
Costume Design by Gabriella Pescucci

## 12. *Orme, Le* (1974)
   … aka *Footprints* (1974)
   … aka Primal Impulse (1974)
   (USA: video title)

Directed by Luigi Bazzoni, Mario Fenelli

CAST
Florinda Bolkan
Caterina Boratto
Nicoletta Elmi
Klaus Kinski – Blackmann
Peter McEnery

Original music by Nicola Piovani
Cinematography by Vittorio Storaro

## 13. *1900* (1976)
   … aka *Nineteen Hundred* (1977) (USA)
   Set in Italy, *1900* follows the lives and relationships of two boys as they grow to manhood. One is born a bastard of peasant stock (Depardieu). The other is born to a wealthy land owner (De Niro). The drama spans almost fifty years, from 1900 to the end of World War II, and deals primarily with the rise of fascism in Italy. The peasants eventually react by supporting communism. The events that shape the destinies of the two main characters are dramatically portrayed.

Directed by Bernardo Bertolucci
Written by Franco Arcalli, Bernardo Bertolucci,

Giuseppe Bertolucci

CAST
Robert De Niro – Alfredo Berlinghieri
Gérard Depardieu – Olmo Dalco
Dominique Sanda – Ada Fiastri Paulhan
Francesca Bertini – Sister Desolata
Laura Betti – Regina
Werner Bruhns – Ottavio Berlinghieri
Stefania Casini – Neve
Sterling Hayden – Leo Dalco
Anna Henkel – Anita
Ellen Schwiers – Amelia
Alida Valli – Signora Pioppo
Romolo Valli – Giovanni
Bianca Magliucca
Giacomo Rizzo – Rigoletto
Pippo Campanini – Don Tarcisio
Paolo Pavesi – Alfredo as a Child
Roberto Maccanti – Olmo as a Child
Antonio Piovanelli – Turo Dalco
Paulo Branco – Orso Dalco
Liu Bosisio – Nella Dalco
Maria Monti – Rosina Dalco
Anna-Maria Gherardi – Eleonora
Demesio Lusardi
Pietro Longari Ponzoni
Angelo Pellegrino
José Quaglio – Aranzini
Clara Colosimo
Mario Meniconi
Carlotta Barilli
Odoardo Dall'aglio – Oreste Dalco
Piero Vida
Vittorio Fanfoni
Alessandro Bosio
Sergio Serafini
Patrizia De Clara
Edda Ferronao
Winni Riva
Fabio Garriba
Nazzareno Natale
Katerina Kosak
Stefania Sandrelli – Anita Foschi
Donald Sutherland – Attila
Burt Lancaster – Berlinghieri

Lisa Harrow
Allen Midgette – Vagabond
Salvator Mureddu – Chief of the King's Guards
Tiziana Senatore – Regina as a Child

Produced by Alberto Grimaldi
Original music by Ennio Morricone
Cinematography by Vittorio Storaro
Film Editing by Franco Arcalli, Enzo Ocone
Production Design by Gianni Quaranta
Costume Design by Gitt Magrini
Makeup Giannetto De Rossi

## 14.  *Scandalo* (1976)
  … aka *Scandal* (1976) (USA)
  … aka *Submission* (1976)

   It is 1940 in France, just before the great invasion of World War II. Eliane (Lisa Gastoni) is a pharmacist who is married to a very dull husband and has a teenage daughter. Eliane is a beautiful woman who has allowed her womanhood to wilt. One evening, a clerk at the pharmacy makes a pass at her when he mistakes Eliane for someone else. She soon lets desire overwhelm her and gradually becomes a slave to her forbidden passion.

Directed by Salvatore Samperi
Written by Ottavio Jemma, Salvatore Samperi

CAST
Antonio Altoviti
Carla Calò – Carmen
Andréa Ferréol – Juliette
Lisa Gastoni – Eliane Michaud
Claudia Marsani – Justine
Franco Nero – Armand
Laura Nicholson
Franco Patano
Raymond Pellegrin – Prof. Henri Michaud

Produced by Silvio Clementelli
Original music by Riz Ortolani
Cinematography by Vittorio Storaro
Film Editing by Sergio Montanari

Production Design by Ezio Altieri
Costume Design by Gitt Magrini

## 15. *Agatha* (1979)

The title of this British movie refers to Agatha Christie, one of the world's most famous mystery writers. In 1926, Christie left her home without warning and created much public speculation as to her whereabouts. Director Michael Apted juxtaposes solemnity with the most trivial of human concerns in his storytelling. Dustin Hoffman portrays a celebrated journalist who falls in love with Christie. Vanessa Redgrave captures perfectly the melancholy and isolation of the character. The picture itself turns suddenly into a thrilling race against time with an exciting but disheartening twist. It is a beautiful film with excellent dialogue and a clever structure. Storaro's cinematography is radiant. Timothy Dalton gives one of his finest performances as a narrow-minded and patronizing husband.

Directed by Michael Apted
Written by Kathleen Tynan, Arthur Hopcraft

CAST
Dustin Hoffman – Wally Stanton
Vanessa Redgrave – Agatha Christie
Timothy Dalton – Colonel Archibald Christie
Helen Morse – Evelyn Crawley
Celia Gregory – Nancy Neele
Paul Brooke – John Foster
Carolyn Pickles – Charlotte Fisher
Timothy West – Kenward
Tony Britton – William Collins
Alan Badel – Lord Brackenbury
Robert Longden – Pettelson
Donald Nithsdale – Uncle Jones
Yvonne Gilan – Mrs. Braithwaite
Sandra Voe – Therapist
Barry Hart – Superintendent MacDonald
David Hargreaves – Sergeant Jarvis
Tim Seely – Capt. Rankin
Jill Summers – Nancy's Aunt
Christopher Fairbank – Luland (as Chris

Fairbank)
Liz Smith – Flora
Peter Arne – Hotel Manager
D. Geoff Tomlinson – Hotel Receptionist
John Joyce – Hotel Waiter
Irene Sutcliffe – Dress Shop Manageress
Anne Francis – Jane
Hope Johnstone – Royal Baths Clerk
John Ludlow – Royal Baths Clerk
Ray Gatenby – Official at Literary Luncheon
Hubert Rees – Official at Literary Luncheon
Tommy Hunter – Pierrot
Pamela Austin – Pierrot
Bert Ward – Pierrot
Harry Segal – Pierrot
Howard Blake – Hotel Trio
Jim Archer – Hotel Trio
Reginald Kilbey – Hotel Trio

Produced by Jarvis Astaire, Gavrik Losey
Original music by Johnny Mandel
Cinematography by Vittorio Storaro
Film Editing by Jim Clark
Casting Mary Selway
Production Design by Shirley Russell
Art Direction Simon Holland
Costume Design by Shirley Russell
Makeup Wally Schneiderman

## 16. *Apocalypse Now* (1979)

Based on Joseph Conrad's *Heart Of Darkness*, this is a brilliant addition to the many Vietnam War movies in existence. Captain Willard is on his mission into Cambodia to assassinate a renegade Green Beret who has set himself up as a God among a local tribe. As Willard descends into the jungle, he is slowly over taken by primitive and hypnotic powers. He is engulfed in the war and insanity. His crew is slowly killed off one by one. Willard becomes the man he was sent to kill.

Directed by Francis Ford Coppola
Written by Joseph Conrad (novel *Heart of Darkness*), Francis Ford Coppola, Michael Herr, John Milius

CAST
Marlon Brando – Colonel Walter E. Kurtz
Robert Duvall – Lieutenant Colonel Kilgore
Martin Sheen – Captain Benjamin L. Willard
Frederic Forrest – Chef (Hicks)
Albert Hall – Chief Phillips
Sam Bottoms – Lance Johnson
Laurence Fishburne – Mr. Clean (Miller) (as Larry Fishburne)
Dennis Hopper – The Photojournalist
G.D. Spradlin – General Corman
Harrison Ford – Colonel Lucas
Jerry Ziesmer – Civilian
Scott Glenn – Colby
Bo Byers – Sergeant MP #1
James Keane – Kilgore's Gunner
Kerry Rossall – Mike from San Diego
Ron McQueen – Injured Soldier
Tom Mason – Supply Sergeant
Cynthia Wood – Playmate of the Year (Carrie Foster)
Colleen Camp – Playmate (Miss May, Terry Teray)
Linda Carpenter – Playmate (Miss August, Sandra Beatty)
Jack Thibeau – Soldier in Trench
Glenn Walken – Lieutenant Carlsen
George Cantero – Soldier with Suitcase
Damien Leake – Machine Gunner
Herb Rice – Roach
William Upton – Spotter
Larry Carney – Sergeant MP #2
Marc Coppola – AFRS Announcer
Daniel Kiewit – Major from New Jersey
Father Elias – Catholic Priest
Bill Graham – Agent
Hattie James – Clean's Mother (voice)
Jerry Ross – Johnny from Malibu
Dick White – Helicopter Pilot
Francis Ford Coppola – Director of TV Crew (uncredited)
R. Lee Ermey – Heliocopter Pilot (uncredited)
Vittorio Storaro – TV Photographer (uncredited)
Produced by John Ashley, Francis Ford Coppola, Gray Frederickson, Eddie Romero
Fred Roos, Mona Skager, Tom Sternberg
Original music by Carmine Coppola, Francis Ford

Coppola, Mickey Hart
Additional music by John Densmore, Robby Krieger, Ray Manzarek, Jim Morrison Richard Wagner (from opera "Die Walküre")
Cinematography by Vittorio Storaro
Film Editing by Lisa Fruchtman, Gerald B. Greenberg, Richard Marks, Walter Murch
Production Design by Dean Tavoularis
Art Direction Angelo P. Graham
Set Decoration George R. Nelson
Costume Design by Charles E. James

## 17. *Luna, La* (1979)
… aka *Luna* (1979) (USA)
A dark, disturbing tale of an incestuous relationship between a mother (Jill Clayburg) and her drug-addicted son.

Directed by Bernardo Bertolucci
Written by Franco Arcalli, Bernardo Bertolucci, Giuseppe Bertolucci, Clare Peploe

CAST
Jill Clayburgh – Caterina Silveri
Matthew Barry – Joe, Her Son
Veronica Lazar – Marina
Renato Salvatori – Communist
Fred Gwynne – Douglas Winter, Her Husband
Tomas Milian – Giuseppe
Alida Valli – Giuseppe's Mother
Elisabetta Campeti – Arianna
Franco Citti – Man in Bar
Roberto Benigni – Upholsterer
Carlo Verdone – Director of Caracalla
Peter Eyre – Edward
Stéphane Barat – Mustafa
Pippo Campanini – Innkeeper
Rodolfo Lodi – Maestro Giancarlo Calo
Shara Di Nepi – Concetta, Caterina's Maid
Jole Silvani – Wardrobe Mistress
Francesco Mei – Barman
Ronaldo Bonac Pchi – Barmen
Mimmo Poli – Piano Mover
Massimiliano Filoni – Piano Mover
Alessandro Vlad – Caracalla Conductor

Laura Betti – Ludovica
Liana Del Balzo – Maestro's Sister
Julian Adamoli – Julian
Enzo Siciliano – Orchestra Conductor in Rome
Nicola Nicoloso – Tenor in "Il travatore"
Mario Tocci – Conte di Luna in "Il Travatore"
Franco Magrini – Doctor
Iole Cecchini – Opera Hairdresser
Fabrizio Polverini – Driver

Produced by Giovanni Bertolucci
Original music by Ennio Morricone
Additional music by Giuseppe Verdi ("Il
Trovatore", "La Traviata" and "Un ballo di
maschera")
Cinematography by Vittorio Storaro
Film Editing by Gabriella Cristiani
Art Direction Maria Paola Maino, Gianni Silvestri
Costume Design by Lina Nerli Tavia
Makeup Giuseppe Banchelli

## 18. *Reds* (1981)

Louise Bryant is a dedicated writer who goes to a lecture one night in 1912. She is mesmerized by John Reed, a radical journalist. Bryant leaves her husband and goes to Greenwich Village with Reed, where she plunges into writing. Among her works is coverage of the 1913 Armory Show of avant-garde art from Europe. Reed is wrapped up in changing the world. Louise stays with playwright Eugene O'Neill for a while, then returns to Reed, who subsequently goes to Russia and covers the 1917 revolution. The use of witnesses to history throughout the film gives it a compelling humanism and increases its interest.

Directed by Warren Beatty
Written by Warren Beatty, Trevor Griffiths

CAST
Warren Beatty – John Reed
Diane Keaton – Louise Bryant
Edward Herrmann – Max Eastman
Jerzy Kosinski – Grigory Zinoviev
Jack Nicholson – Eugene O'Neill

Paul Sorvino – Louis Fraina
Maureen Stapleton – Emma Goldman
Nicolas Coster – Paul Trullinger
M. Emmet Walsh – Speaker - Liberal Club
Ian Wolfe – Mr. Partlow
Bessie Love – Mrs. Partlow
MacIntyre Dixon – Carl Walters
Pat Starr – Helen Walters
Eleanor D. Wilson – Mrs. Reed
Max Wright – Floyd Dell
George Plimpton – Horace Whigham
Harry Ditson – Maurice Becker
Leigh Curran – Isa Ruth
Kathryn Grody – Crystal Eastman
Brenda Currin – Marjorie Jones
Nancy Duiguid – Jane Heap
Norman Chancer – Barney
Dolph Sweet – Big Bill Haywood
Ramon Bieri – Police Chief
Jack O'Leary – Pinkerton Guard
Gene Hackman – Pete Van Wherry
Gerald Hiken – Dr. Lorber
William Daniels – Julius Gerber
Dave King – Allan Benson
Joseph Buloff – Joe Volski
Stefan Gryff – Alex Gomberg
Denis Pekarev – Interpreter in Factory
Roger Sloman – V.I. Lenin
Stuart Richman – L. Trotsky
Oleg Kerensky – A. Kerensky
Nikko Seppala – Young Bolshevik Soldier
John J. Hooker – Senator Overman
Shane Rimmer – MacAlpine
Jerry Hardin – Harry
Jack Kehoe – Eddie
Christopher Malcolm – C.I.P. Party Member
Tony Sibbald – C.I.P. Party Member
R.G. Armstrong – Government Agent
Josef Sommer – State Department Official
Jan Triska – Karl Radek
Åke Lindman – Scandinavian Escort
Pertti Weckström – Finnish Doctor
Nina Macarova – Russian Nurse
Jose De Fillippo – Russian Doctor
Andress La Casa – Little Boy
Roger Baldwin – Witness

Henry Miller – Witness
Adela Rogers St. Johns – Witness (uncredited)
Dora Russell – Witness
Scott Nearing – Witness
Tess Davis – Witness
Heaton Vorse – Witness
Hamilton Fish – Witness
Isaac Don Levine – Witness
Rebecca West – Witness
Will Durant – Witness
Will Weinstone – Witness
Emmanuel Herbert – Witness
Arne Swabeck – Witness
Adele Nathan – Witness
George Seldes – Witness
Kenneth Chamberlain – Witness
Blanche Hays Fagen – Witness
Galina von Meck – Witness
Art Shields – Witness
Andrew Dasburg – Witness
Hugo Gellert – Witness
Dorothy Frooks – Witness
George Jessel – Witness (uncredited)
Jacob Bailin – Witness
John Ballato – Witness
Lucita Williams – Witness
Bernadine Szold-Fritz – Witness
Jessica Smith – Witness
Harry Carlisle – Witness
Arthur Meyer – Witness
Dwayne Brenna – Extra (uncredited)
Anthony Forrest – Harry Reed (uncredited)

Produced by Warren Beatty, David Leigh
MacLeod, Simon Relph
Original music by Stephen Sondheim
Non-original music by Pierre Degeyter
Cinematography by Vittorio Storaro
Film Editing by Dede Allen, Craig McKay
Production Design by Michael Seirton, Richard
Sylbert
Art Direction Simon Holland
Costume Design by Shirley Russell

## 19. *One From the Heart* (1982)

The five-year anniversary of Hank and Frannie commences on the Fourth of July in Las Vegas. Instead of celebrating, they have a fight. Frannie is a "flake" and Hank is a "stick-in-the-mud." After breaking up, Hank meets an exotic circus performer and Frannie meets a charming waiter/singer. Storaro's breakthrough film for the use of translucent screens and his master dimmer board.

Directed by Francis Ford Coppola
Written by Armyan Bernstein, Francis Ford
Coppola

CAST
Frederic Forrest – Hank
Teri Garr – Frannie
Raul Julia – Ray
Nastassja Kinski – Leila
Lainie Kazan – Maggie
Harry Dean Stanton – Moe
Allen Garfield – Restaurant Owner (as Allen
Goorwitz)
Jeff Hamlin –  Airline Ticket Agent
Italia Coppola – Couple in Elevator
Carmine Coppola – Couple in Elevator
Edward Blackoff – Understudies
James Dean – Understudies
Rebecca De Mornay – Understudies
Javier Grajeda – Understudies
Cynthia Kania – Understudies
Monica Scattini – Understudies

Produced by Armyan Bernstein, Gray
Frederickson, Bernard Gersten, Fred Roos  Mona
Skager
Original music by Tom Waits
Cinematography by Ronald Víctor García, Vittorio
Storaro
Film Editing by Rudi Fehr, Anne Goursaud, Randy
Roberts
Casting Jennifer Shull
Production Design by Dean Tavoularis
Art Direction Angelo P. Graham
Set Decoration Gary Fettis, Leslie McCarthy-

Frankenheimer
Costume Design by Ruth Morley
Makeup Jeff Angell, Jene Fielder

## 20. *Wagner* (1983) (TV Miniseries)

Everything you wanted to know about Wagner's life and work. The large canvas runs the gamut, from before the 1848 revolution and Wagner's exile in Switzerland, to his rescue by King Ludwig II of Bavaria, to his last triumph at Bayreuth. Wagner's musical thought and politics are examined in the context of his life and times.

Directed by Tony Palmer
Written by Charles Wood

CAST
Richard Burton – Richard Wagner
Vanessa Redgrave – Cosima von Bulow
László Gálffi – King Ludwig II of Bavaria
John Gielgud – Pfistermeister
Ralph Richardson – Pfordten
Laurence Olivier – Pfeufer
Gemma Craven – Minna
Ekkehard Schall – Liszt
Ronald Pickup – Nietzsche
Miguel Herz-Kestranek – Hans von Bülow
Richard Pasco – Otto Wesendonck
Marthe Keller – Mathilde Wesendonck
Gwyneth Jones – Malvina von Carolsfeld
Peter Hofmann – Schnorr von Carolsfeld
Franco Nero – Crespi
Joan Greenwood – Frau Dangl
William Walton – King Friedrich August II of Saxony
Andrew Cruickshank – Minister Bär/Narrator
Peter Wehle – Bailiff
Gerhard Bronner – Bailiff
Bill Fraser – Mayor of Bayreuth
Claudia Solti – Isolde von Bülow
Christopher Gable – Peter Cornelius
Yvonne Kenny – Frau Dustmann
Peter Woodthorpe – French Agent
Bernadette Schneider – Judith Gautier
Adele Leigh-Enderl – Frau Heim

Felix Franchy – Prince Hohenlohe
Patrick Rollin – Eugene Laussot
Liza Goddard – Jessie Laussot
Niall Toibin – Lutz
Arthur Lowe – Meser
Daphne Wagner – Princess Metternich
Lisa Kreuzer – Friederike Meyer
Vernon Dobtcheff – Meyerbeer
Jess Thomas – Albert Niemann
Jean-Luc Moreau – Petipa
Prunella Scales – Frau Pollert
Corin Redgrave – Dr. Pusinelli
Barbara Leigh-Hunt – Queen Mother
Stephen Oliver – Richter
Gabriel Byrne – Karl Ritter
John Shrapnel – Semper
Cyril Cusack – Sulzer
Arthur Denberg – Prince Paul Taxis
Joan Plowright – Mrs. Taylor
Manfred Jung – Unger
Brook Williams – Various Outraged Persons
Heinz Zednik – Ander
Péter Andorai – Bakunin
Mark Burns – Baron von Hulsen
Lambert Hamel – Betz
Klaus Knuth – Bavarian Guide
Jürgen Cziesla – Bavarian Man
Erwin Steinhauer – Wilhelm Baumgartner
Ernest Lenart – Brandt
Arthur Kottas – Captain of Hussars
Marita Phillips – Princess Caroline
Peter Ohme – Treasury Clerk
Erland Erlandsen – Duflipp
Albert Rueprecht – Editor
Osman Ragheb – Professor Ettmüller
Mátyás Usztics – Franz
Götz von Langheim – Feustal
Eva-Christina Prader – Russian Girlfriend
Donald Arthur – Franz Hagenbuch
László Horváth – Dr. Hanslick
Peter Arens – Georg Herwegh
Orlando Montez – Italian Agent
Günther Panak – Journalist
Alfred Pfeifer – Lasalle
Christoph Dittrich – Levi
Sigfrit Steiner – King Ludwig I of Bavaria

Zoltán Gera – Lüttichau
Teréz Bod – Frau Lüttichau
Maximilian Wolters – Theatre Manager
Emanuel Schmied – Uncle Max
Rudolf Rath – Mendes
Edd Stavjanik – Wine Merchant
Peter Wolsdorff – Alexander Müller
Mary Martlew-Escher – Frau Müller
Jack Kirk – Musician
Edit Rujz – Natalie
Jan Biczycki – Perfall
Peter Holliger – Photographer
Franz Gary – Porter
Janos Engyel – Karl Reissiger
Stephan Paryla – Röckel
Heinz Weiss – Royer
George Pravda – Dr. Schauss
Roger Murbach – Herr Schott
Zsuzsa Mányai – Madame Schwabe
Helmut Janatsch – Secretary
Philipp Brammer – Siegfried
Martina Krischka – Sophia
Hanno Pöschl – Police Spy
Michael Janisch – Standhartner
Otto Clemens – Karl Tausig
Marta Lukin – Madame Tedesco
Reinhold Olszewski – Tinsmith
Georges Claisse – Uhlig
François-Eric Gendron – Villiers
Jörg Wille – Dr. Wille

Produced by Alan Wright
Music by Richard Wagner
Cinematography by Vittorio Storaro
Film Editing by Tony Palme
Casting Renate Arles
Art Direction Andras Langmar, Terry Pritchard
Makeup Ron Berkeley

## 21. *Ladyhawke* (1985)

A manhunt commences when Philipe Gastone, a thief, escapes from the dungeon at Aquila. A Captain Navarre befriends Gastone, who had been nearly captured. Navarre himself is hunted by the bishop ever since he escaped with the Lady Isabeau, for whom the bishop has great lust. The bishop has placed a curse on Navarre and Isabeau that turns Navarre into a wolf and Isabeau into a hawk. Gastone and Navarre enter the heavily guarded city to bring justice to the Bishop.

Directed by Richard Donner
Written by Edward Khmara, Michael Thomas, Tom Mankiewicz

CAST
Matthew Broderick – Phillipe
Rutger Hauer – Etienne Navarre
Michelle Pfeiffer – Isabeau
Leo McKern – Imperius
John Wood – Bishop
Ken Hutchison – Marquet
Alfred Molina – Cezar
Giancarlo Prete – Fornac
Loris Loddi – Jehan
Alessandro Serra – Mr. Pitou
Charles Borromel – Insane Prisoner
Massimo Sarchielli – Innkeeper
Nicolina Papetti – Mrs. Pitou
Russell Kase – Lieutenant
Don Hudson – Guard on Cart
Gregory Snegoff – Cart Driver
Gaetano Russo – Guard in the Cell
Rod Dana – Guard at the City Gate
Stefano Horowitzo – Bishop's Bodyguard
Paul Tuerpe – Guard
Venantino Venantini – Bishop's Secretary
Marcus Berensford – Acolyte
Valerie O'Brian – Peasant Girl
Nanà Cecchi – Bishop's Woman

Produced by Harvey Bernhard, Richard Donner, Lauren Shuler Donner
Original music by John Dowland, Andrew Powell
Cinematography by Vittorio Storaro
Film Editing by Stuart Baird
Casting Marion Dougherty
Production Design by Wolf Kroeger
Art Direction Ken Court, Giovanni Natalucci
Costume Design Nanà Cecchi
Makeup Giancarlo Del Brocco

**22. *Peter the Great*** (1986) (TV Miniseries)

The continuing struggles of Peter I, tsar of Russia in 1682, are dramatically portrayed. Peter's difficulties with his sister Sophia and the Streltsy, an important Russian military corps, are illustrated, along with the efforts of Peter to transform Russia into an "all European" country, importing technology, scientists and military tactics.

Directed by Marvin J. Chomsky, Lawrence Schiller
Written by Edward Anhalt, Robert K. Massie (book)

CAST
Maximilian Schell – Peter the Great
Vanessa Redgrave – Sophia
Omar Sharif – Prince Feodor Romodanovsky
Trevor Howard – Sir Isaac Newton
Laurence Olivier – King William of Orange
Helmut Griem – Alexander Menshikov
Jan Niklas – Young Peter the Great
Elke Sommer – Charlotte
Renée Soutendijk – Anna Mons
Ursula Andress – Athalie
Mel Ferrer – Frederich
Hanna Schygulla – Catherine Skevronskaya
Mike Gwilym – Shafirov
Günther Maria Halmer – Count Tolstoy
Jan Malmsjö – The Patriarch
Lilli Palmer – Natalya
Geoffrey Whitehead – Prince Golitsyn
Jeremy Kemp – General Patrick Gordon
Boris Plotnikov – Alexis
Roman Filippov – Danielo Menshikov
Vsevolod Larionov – Prince Sukhorukov
Natasha Andrejchenko – Eudoxia
Algis Arlauskas – Theodosius
Philip Bowen – Walter Buschhoff
Dimitri Chernigovsky – Michael Menshikov
Denis DeMarne – Old Peter
Carl Duering
Christoph Eichhorn – Karl XII, King of Sweden
Luba Ghermanova – Afrosina
Burkhard Heyl
Vladimir Ilyin
Vera Kharybina
Michael MacKenzie
Graham McGrath – 10 year old Peter
George Murcell
Ulli Philipp – Louise

Produced by Marvin J. Chomsky
Original music by Laurence Rosenthal
Cinematography by Vittorio Storaro
Film Editing by Bill Parker

**23. *Last Emperor, The*** (1987)
… aka *Ultimo imperatore, L'* (1987) (Italy)

The panoramic story of Pu Yi, the last of the emperors of China, is sweepingly portrayed, from his lofty birth and brief reign in the Forbidden City as the object of worship by half a billion people through his abdication, decline and dissolute lifestyle. Exploited by the invading Japanese, he finally comes to live an obscure existence as an anonymous peasant worker in the People's Republic.

Directed by Bernardo Bertolucci
Written by Bernardo Bertolucci, Mark Peploe, Enzo Ungari

CAST
John Lone – Pu Yi (Adult)
Joan Chen – Wan Jung
Peter O'Toole – Reginald Johnston (R.J.)
Ruocheng Ying – The Governor
Victor Wong – Chen Pao Shen
Dennis Dun – Big Li
Ryuichi Sakamoto – Amakasu
Maggie Han – Eastern Jewel
Ric Young – Interrogator
Vivian Wu – Wen Hsiu (as Wu Jun Mei)
Cary-Hiroyuki Tagawa – Chang
Jade Go – Amah
Fumihiko Ikeda – Yoshioka
Richard Vuu – Pu Yi (3 years)
Tsou Tijger – Pu Yi (8 years)
Tao Wu – Pu Yi (15 years)
Guang Fan
Henry Kyi – Pu Chieh (7 years)

Alvin Riley – Pu Chieh (14 years)
Lisa Lu – Tzu Hsui
Hideo Takamatsu – General Ishikari
Hajime Tachibana – Japanese Translator
Liangbin Zhang – Big Foot
Basil Pao – Prince Chun
Jiang Xi Ren – Lord Chamberlain
Wenjie Huang – Hunchback
Kaige Chen – Captain of ImperialGuard (as Chen Kai Ge)
Dong Liang – Lady Aisin-Gioro
Zhendong Dong – Old Doctor
Jiechen Dong – Doctor
Huaikuei Soong – Lung Yu
Ruzhen Shao – First High Consort
Constantine Gregory – Oculist
Yu Li – Second High Consort
Guangli Li – Third High Consort
Tianmin Zhang – Old Tutor
Hongnian Luo – Sleeping Old Tutor
Shihong Yu – Hsiao Hsiu
Xu Chunqing – Grey Eyes
Jun Wu – Wen Hsiu (12 years)
Jingping Cui – Lady of the Pen
Hai Wu – Republican Officer
Junguo Gu – Tang
Lucia Hwong – Lady of the Book
Fusheng Li – Minister of Trade
Shu Chen – Chang Chinghui
Shuyan Cheng – Lady Hiro Saga
Xu Tongrui – Captain of Feng's Army
Daxing Zhang – Tough Warder
Ruigang Zu – Second Warder
Yuan Jin – Party Boss
Akira Ikuta – Japanese Doctor
Michael Vermaaten – American
Matthew Spender – First Englishman
Hongxiang Cai – Scarface
Xinmin Cui – Japanese Bodyguard
Zhenduo Li – Dignitary
Shigang Luo – Chang Chinghui's secretary
Guang Ma – Japanese Bodyguard
Biao Wang – Prisoner
Baozong Yang – General Yuan Shikai
Hongchang Yang – Scribe
Lingmu Zhang – Emperor Hiro Hito

Produced by Franco Giovale, Joyce Herlihy, Jeremy Thomas
Original music by David Byrne, Ryuichi Sakamoto, Cong Su
Cinematography by Vittorio Storaro
Film Editing by Gabriella Cristiani
Production Design by Ferdinando Scarfiotti
Art Direction Maria-Teresa Barbasso, Gianni Giovagnoni, Gianni Silvestri
Costume Design by James Acheson
Makeup Fabrizio Sforza

## 24. *Ishtar* (1987)

To continue their hapless careers, two very bad lounge singers get booked to play the Ishtar Hilton. They unwittingly become pawns in an international power play between the CIA, the Emir of Ishtar and rebels trying to overthrow the Emir's regime.

Directed by Elaine May
Written by Elaine May

CAST
Warren Beatty – Lyle Rogers
Dustin Hoffman – Chuck Clarke
Isabelle Adjani – Shirra Assel
Charles Grodin – Jim Harrison
Jack Weston – Marty Freed
Tess Harper – Willa
Carol Kane – Carol
Aharon Ipalé – Emir Yousef
Fijad Hageb – Abdul
David Margulies – Mr. Clarke
Rose Arrick – Mrs.Clarke
Julie Garfield – Dorothy
Cristine Rose – Siri Darma
Robert V. Girolami – Bartender
Abe Kroll – Mr.Thomopoulos
Hannah Kroll – Mrs.Thomopoulos
Herb Gardner – Rabbi Pierce
Bill Moor – U.S.Consulate
Edgar Smith – Professor Barnes
J.C. Cutler – Omar
Bill Bailey – General Westlake
Ian Gray – Manager Chez Casablanca

Maati Zaari – Porter
Larbi Bouhaddane – Taxi Driver
Fred Melamed – Caid of Assari
Ron Berglas – CIA Agent (as Ron Berglass)
Neil Zevnik – CIA Agent
Matt Frewer – CIA Agent
Alex Hyde-White – CIA Agent
Stefan Gryff – KGB Agent
Alexei Jawdokimov – KGB Agent
Phillip Schopper – Waiter
Aziz Ben Driss – Waiter Chez Casablanca
Kamarr – Maitre D'Chez Casablanca
Eddy Nedari – Mohamad. the Camel Seller
Adam Hussein – Mohamad. the Camel Seller
George Masri  – Mohamad. the Camel Seller
Warren Clarke – English Gunrunner
Arthur Brauss – German Gunrunner
Sumar Khan – Ishtari Gunrunner
Jon Paul Morgan – Djellabah Seller
Nadim Sawalha – Rug Shop Owner/Camel Seller
Haluk Bilginer – Guerilla Leader
Stuart Abramson – Screamin' Honkers
John Freudenheim – Screamin' Honkers
Bruce Gordon – Screamin' Honkers
Paul Standig – The Swing
Joseph Gmerek – The Swing
John Trumpbour – The Swing
Marie Jean-Charles – Teacher's Daughters
Patrice Jean-Charles – Teacher's Daughters
Danielle Jean-Charles – Teacher's Daughters

Produced by Warren Beatty, David Leigh
MacLeod, Nigel Wooll
Original music by Bahjawa, Dave Grusin
Cinematography by Vittorio Storaro
Film Editing by Richard P. Cirincione. William
Reynolds. Stephen A. Rotter, William S. Scharf
Production Design by Paul Sylbert
Set Decoration Jim Erickson
Costume Design by Anthony Powell

## 25. *Tucker: The Man and His Dream*
(1988)

Based on a true story. After World War II ends,
Preston Tucker vows to realize his dream to pro-
duce the best car ever made. It is a grand scheme,
but with the assistance of Abe Karatz and some
impressive salesmanship on his own part, Tucker
obtains financial backing and begins to build his
factory. The film also has many parallels with direc-
tor Coppola's efforts to build his own movie studio,
American Zoetrope.

Directed by Francis Ford Coppola
Written by Arnold Schulman, David Seidler

CAST
Jeff Bridges – Preston Tucker
Joan Allen – Vera Tucker
Martin Landau – Abe Karatz
Frederic Forrest – Eddie Dean
Mako – Jimmy Sakuyama
Elias Koteas –  Alex Tremulis
Christian Slater – Junior
Nina Siemaszko – Marilyn Lee Tucker
Anders Johnson – Johnny Tucker
Corin Nemec – Noble (as Corky Nemec)
Marshall Bell – Frank
Jay O. Sanders – Kirby
Peter Donat – Kerner
Dean Goodman – Bennington/Drew Pearson's
Voice
John X. Heart – Ferguson's Agent
Don Novello – Stan
Patti Austin – Millie
Sandy Bull – Stan's Assistant
Joe Miksak – Judge
Scott Beach – Floyd Cerf
Roland Scrivner – Oscar Beasley
Dean Stockwell – Howard Hughes
Bob Safford – Narrator
Ron Close – Fritz
Joe Flood – Dutch
Leonard Gardner – Gas Station Owner
Bill Bonham – Garage Owner
Abigail Van Alyn – Ferguson's Secretary #1
Taylor Gilbert – Ferguson's Secretary #2
David Booth – Man in Hall
Jessie Nelson – Woman on Steps
Al Hart – Newscaster (voice)
Cab Covay – Security Guard

James Cranna – Man in Audience
Bill Reddick – Board Member
Ed Loerke – Mayor
Jay Jacobus – Head Engineer
Anne Lawder – Bennington's Secretary
Jeanette Lana Sartain – Singing Girl
Mary Buffett – Singing Girl
Annie Stocking – Singing Girl
Michael McShane – Recording Engineer
Hope Alexander-Willis – Tucker's Secretary #1
Taylor Young – Tucker's Secretary #2
Jim Giovanni – Police Sergeant
Joe Lerer – Reporter at Trial
Morgan Upton – Ingram
Ken Grantham – SEC Agent
Mark Anger – Blue
Al Nalbandian – Jury Foreman
Lloyd Bridges – Senator Homer Ferguson (uncredited)
Lawrence Menkin – Doc (as Larry Menkin)

Produced by Teri Fettis, Fred Fuchs, George Lucas, Fred Roos
Original music by Carmine Coppola, Joe Jackson (additional music)
Cinematography by Vittorio Storaro
Film Editing by Priscilla Nedd-Friendly
Casting Janet Hirshenson, Jane Jenkins
Production Design by Dean Tavoularis
Art Direction Alex Tavoularis
Set Decoration Armin Ganz
Costume Design by Milena Canonero
Makeup Richard Dean

## 26. *New York Stories* (1989)
### (segment *Life Without Zoe*)

Three stories happening in New York. Zoe, a precocious child living in a luxurious New York apartment, is neglected by her very busy parents.

Directed by Francis Ford Coppola
Written by Francis Ford Coppola, Sofia Coppola

CAST
Julie Kavner – Treva

Heather McComb – Zoe
Talia Shire – Charlotte
Gia Coppola – Baby Zoe
Giancarlo Giannini – Claudio
James Keane – Jimmy
Don Novello – Hector
Bill Moor – Mr. Lilly
Tom Mardirosian – Hasid
Jenny Nichols – Lundy
Gina Scianni – Devo
Diane Lin Cosman – Margit
Selim Tlili – Abu
Robin Wood-Chappelle – Gel
Celia Nestell – Hillary
Alexandra Becker – Andrea
Adrien Brody – Mel
Michael Higgins – Robber
Chris Elliott – Robber
Thelma Carpenter – Maid
Carmine Coppola – Street Musician
Carole Bouquet – Princess Saroya
Jojo Starbuck – Ice Skater
Nick Nolte – Lionel Dobie
Patrick O'Neal – Phillip Fowler
Rosanna Arquette – Paulette
Phil Harper – Businessman
Kenneth J. McGregor – Suit
David Cryer – Suit
Paul Geier – Suit
Jesse Borrego – Reuben Toro
Gregorij von Leitis – Kurt Bloom
Steve Buscemi – Gregory Stark
LoNardo – Woman at Blind Alley
Peter Gabriel – Himself
Mark Boone Junior – Hank
Illeana Douglas – Paulette's Friend
Paul Mougey – Guy at Blind Alley
Debbie Harry – Girl at Blind Alley
Victor Argo – Cop
Victor Trull – Maitre d'
Richard Price – Artist at Opening
Brigitte Bako – Young Woman
Holly Marie Combs   (uncredited)
Kirsten Dunst – Lisa's Daughter (uncredited)
Matthew T. Gitkin – Private First Class (uncredited)

George Rafferty – Squiggy
Martin Scorsese – Man Having Picture taken with Lionel Dobie

Produced by Barbara De Fina
Original music by Carmine Coppola
Cinematography by Vittorio Storaro
Film Editing by Thelma Schoonmaker
Casting Ellen Lewis
Production Design by Kristi Zea
Set Decoration George DeTitta Jr.
Costume Design by John A. Dunn
Francesca Paris – hair stylist

## 27. *Dick Tracy* (1990)

Tess Trueheart just wants to settle down to a quiet life with her boyfriend, detective Dick Tracy. But that's not going to happen until Tracy has wrapped up the dirty dealings going on around town by Big Boy Caprice and his bizarre bunch of criminal cohorts. Plus, Tracy has to deal with the glamorous Breathless Mahoney. Primary colors never looked so vibrant as in this comic strip movie.

Directed by Warren Beatty
Written by Warren Beatty, Jim Cash, Jack Epps Jr., Chester Gould (comic strip)

CAST
Warren Beatty – Dick Tracy
Charlie Korsmo – The Kid
Glenne Headly – Tess Trueheart
Al Pacino – Big Boy Caprice
Madonna – Breathless Mahoney
William Forsythe – Flattop
Ed O'Ross – Itchy
Seymour Cassel – Sam Kathcum
James Keane – Pat Patton
Charles Durning – Brendan
Mandy Patinkin – 88 Keys
R.G. Armstrong – Pruneface
James Tolkan – Numbers
Dustin Hoffman – Mumbles
Dick Van Dyke – D.A. Fletcher

Paul Sorvino – Lips Manlis
Henry Silva – Influence
Estelle Parsons – Mrs. Trueheart
James Caan – Spaldoni
Mike Mazurki – Old Man at Hotel
Michael Donovan O'Donnell – Mr. Gillecuddy
Jim Wilkey – Stooge
Stig Eldred – Shoulders
Neil Summers – The Rodent
Chuck Hicks – The Brow
Lawrence Steven Meyers – Little Face
Marvelee Cariaga – Soprano
Michael Gallup – Baritone
Allen Garfield – Reporter
John Schuck – Reporter
Charles Fleischer – Reporter
Robert Costanzo – Lips' Bodyguard
Jack Kehoe – Customer at Raid
Marshall Bell – Lips' Cop
Michael G. Hagerty – Doorman
Lew Horn – Lefty Moriarty
Arthur Malet – Diner Patron
Tom Signorelli – Mike
Tony Epper – Steve the Tramp
Kathy Bates – Mrs. Green
Jack Goode Jr. – Lab Technician
Ray Stoddard – Lab Technician
Hamilton Camp – Store Clerk
Ed McCready – Cop at Tess'
Colm Meaney – Cop at Tess'
Catherine O'Hara – Texie Garcia
Robert Beecher – Ribs Mocca
Bert Remsen – Bartender
Frank Campanella – Judge Harper
Sharmagne Leland-St. John – Club Ritz Patron
Bing Russell – Club Ritz Patron
Michael J. Pollard – Bug Bailey
Tom Finnegan – Uniform Cop at Ritz
Billy Clevenger – Newspaper Vendor
John Moschitta Jr. – Radio Announcer (voice)
Ned Claflin – Radio Announcer
Neil Ross – Radio Announcer (voice)
Walker Edmiston – Radio Announcer (voice)
Ian Wolfe – Forger
Mary Woronov – Welfare Person
Henry Jones – Night Clerk

Rita Bland – Dancer
Lada Boder – Dancer
Dee Hengstler – Dancer
Liz Imperio – Dancer
Michelle Johnston – Dancer
Karyne Ortega – Dancer
Karen Russell – Dancer
Tamara Carrera – Cigarette Girl (uncredited)
Bernie Jones – Night Club Musician (uncredited)
Bruce Mahler – Reporter (uncredited)

Produced by Warren Beatty, Jon Landau, Art Linson, Floyd Mutrux,
Barrie M. Osborne, Jim Van Wyck
Original music by Danny Elfman, Andy Paley (songs), Stephen Sondheim (songs)
Cinematography by Vittorio Storaro
Film Editing by Richard Marks
Casting Jackie Burch
Production Design by Richard Sylbert
Art Direction Harold Michelson
Set Decoration Rick Simpson
Costume Design by Milena Canonero
Makeup Department
John Caglione Jr. – special character makeup
Hallie D'Amore – assistant makeup artist
Richard Dean – makeup consultant
Doug Drexler – special character makeup
Lynda Gurasich – hair stylist
Virginia G. Hadfield – assistant hair stylist
Kevin Haney – key character makeup
Cheri Minns – makeup artist
Ve Neill – special character makeup
Craig Reardon

## 28. *Sheltering Sky, The* (1990)

… aka *Tè nel deserto, Il* (1990) (Italy)

Two American artists, Port and Kit Moresby, travel aimlessly throughout Africa, searching for the key to renew their relationship. The flight to exotic landscapes only pulls them into greater despair in this shimmering study of two privileged and beautiful people enmeshed in ennui.

Directed by Bernardo Bertolucci
Written by Bernardo Bertolucci, Paul Bowles

(novel), Mark Peploe
CAST
Debra Winger – Kit
John Malkovich – Port
Campbell Scott – Tunner
Jill Bennett – Mrs. Lyle
Timothy Spall – Eric Lyle
Eric Vu-An – Belqassim
Amina Annabi – Mahrnia
Philippe Morier-Genoud – Captain Broussard
Sotigui Kouyaté – Abdelkader (as Sotigui Kouyate)
Tom Novembre – French Immigration Officer
Ben Smaïl – Smail
Kamel Cherif – Ticket Seller
Afifi Mohamed – Mohamed
Brahim Oubana – Young Arab
Carolyn De Fonseca – Miss Ferry
Veronica Lazar – Nun
Rabea Tami – Blind Dancer
Nicoletta Braschi – French Woman
Menouer Samiri – Bus Driver
Keltoum Alaoui – Woman in Hotel du Ksar
Mohamed Ixa – Caravan Leader
Ahmed Azoum – Young Tuareg
Alghabid Kanakan – Young Tuareg
Gambo Alkabous – Young Tuareg
Sidi Kasko – Young Tuareg
Azahra Attayoub – Belqassim's Wife
Maghnia Mohamed – Belqassim's Wife
Oumou Alghabid – Belqassim's Wife
Sidi Alkhadar – Little Sidi
Paul Bowles – Narrator (voice)

Produced by William Aldrich, Jeremy Thomas
Original music by Richard Horowitz, Ryuichi Sakamoto
Cinematography by Vittorio Storaro
Film Editing by Gabriella Cristiani
Casting Juliet Taylor
Production Design by Ferdinando Scarfiotti, Gianni Silvestri
Art Direction Andrew Sanders
Costume Design by James Acheson
Makeup Department Linda Armstrong, Paul Engelen, Colin Jamieson
Hair stylist Barry Richardson

### 29. *Writing with Light: Vittorio Storaro* (1992)

### 30. *Tosca: In the Settings and at the Times of Tosca* (1992) (TV)

Puccini's *Tosca* is one of the most famous operas in the Western world. Placido Domingo and Catherine Malfitano are superb in this production. Malfitano does very well as Tosca with her dramatic soprano voice and Domingo's Mario Cavaradossi is well played. Jose Carrera's Cavaradossi is wonderful, and Raimondi's delight in portraying the evil Scarpia is obvious. Puccini's melodies and well orchestrated music are timeless.

Directed by Brian Large (live video) Giuseppe Patroni-Griffi

CAST
Catherine Malfitano – Tosca
Plácido Domingo – Mario Cavaradossi
Ruggero Raimondi – Scarpia
Zubin Mehta – Conductor/Himself
Music by Giacomo Puccini
Cinematography by Vittorio Storaro
Other crew Fabio Zamarion camera operator

### 31. *Little Buddha* (1993)

Searching for the reincarnation of his dead teacher, Lama Norbu comes to Seattle. Norbu is led to young Jesse Conrad; Raju, a boy from Kathmandu; and an Indian girl. The three children journey to Bhutan, where they must undergo a test to prove which is the true reincarnation. Interspersed with this narrative is the story of the prince Siddhartha, eventually known as the Buddha. Siddhartha's spiritual journey from ignorance to true enlightenment is beautifully and movingly traced.

Directed by Bernardo Bertolucci
Writing credits Bernardo Bertolucci, (story) Mark Peploe, Rudy Wurlitzer

CAST
Keanu Reeves – Siddhartha
Ruocheng Ying – Lama Norbu
Chris Isaak – Dean Conrad
Bridget Fonda – Lisa Conrad
Alex Wiesendanger – Jesse Conrad
Raju Lal – Raju
Greishma Makar Singh – Gita
Sogyal Rinpoche – Kenpo Tensin
Ven. Khyongla Rato Rinpoche – Abbot
Ven. Geshe Tsultim Gyelsen – Lama Dorje
Jo Champa – Maria
Jigme Kunsang – Champa
Thubten Jampa – Punzo
Surehka Sikri – Sonali
T.K. Lama – Sanjay
Doma Tshomo – Ani-La
Mantu Lal – Mantu
Mountain Yogi – Mountain Yogi
Rinzin Dakpa – Oracle
Rudraprasad Sengupta – King Suddhodhana
Kanika Pandey – Queen Maya
Rajeshwari Sachdev – Yasodhara
Santosh Bangera – Channa
Vijay Kashyap – Vizir
Bhisham Sahni – Asita
Madhu Mathur – Prajapati
Anupam Shyam – Lord Mara
Ruchi Mathur – Queen's Assistant
Rashid Mastaan – Beggar
S.S. Pandey – Old Musician
Saddiya Siddiqui – Temptation Girl
Tarana Ramakrishnan – Temptation Girl
Antia Thakur – Temptation Girl
Anu Chetri – Temptation Girl
Kavita Hahat – Temptation Girl
Nagabab Shyam – Ascetics
Mahana Amar – Ascetics
Chitra Mandal – Ascetics
Narmadapuree – Ascetics
Kumar Lingeshewer – Ascetics
Nirmala – Village Girl
Ailsa Berk – Elephant
Rhupten Kalsang – Sanjay
Kyongla Rato Rinpoche – The Abbot

Produced by Jeremy Thomas
Original music by Ryuichi Sakamoto
Cinematography by Vittorio Storaro
Film Editing by Pietro Scalia
Production Design by James Acheson
Art Direction Gianni Giovagnoni
Costume Design by James Acheson
Makeup Peter Frampton
Hair stylist Martin Samuel

### 32. *Flamenco* (de Carlos Saura) (1995)

Through a series of simply backlit screens, a hall slowly fills with performers. We hear a narrator, who informs us that flamenco came from Andalucia as a mix of Greek psalm, Mozarabic dirges, Castillian ballad, Jewish laments, Gregorian chant, African rhythms and Persian and gypsy melodies. Thirteen rhythms of flamenco are presented in this film, each with song, guitar and dance. We experience the up-tempo bularías, a moody farruca, a tormented martinete and a lively fandango de huelva. There are also tangos, a taranta, alegrías, siguiriyas, soleás, a guajira of dignified women, a petenera about death, villancicos and a rhumba finale. The only audience is that of the other performers in this tasteful exploration of very unique music and dance.

Directed by Carlos Saura
Written by Carlos Saura

CAST
Enrique Morente
José Meneses
José Merce
Marlo Maya
Matilde Coral
Manuela Carrasco
Joaquín Cortés
Lola Flores
Lole
Paco Luca
Paco de Lucía
Manuel
Manolo Sanlúcar

Produced by Juan Lebrón, José López Rodero
Cinematography by Vittorio Storaro
Film Editing by Pablo González del Amo
Production Design by Rafael Palmero
Costume Design by Amelia
Second Unit Director or Assistant Director
Humberto Cornejo (as Cornejo)
Carlos Saura Medrano
Sound Department Gerry Humphreys

### 33. *Taxi* (1996)

A young girl fails an exam at school and is forced by her father, a taxi driver, to learn his profession. She soon discovers that her father is also a member of a racist group bent on eliminating colored people, homosexuals and transvestites. That doesn't stop her from falling in love with a young man who also drives a taxi and is a member of this neo-fascist group.

Directed by Carlos Saura
Written by Santiago Tabernero
CAST
Ingrid Rubio – Paz
Carlos Fuentes – Dani
Ágata Lys – Reme
Ángel de Andrés López – Velasco
Eusebio Lázaro – Calero
Francisco Maestre – Niño
Maite Blasco – Mari

Produced by Fernando Bauluz, Javier Castro, Concha Díaz, Ricardo Evole
Original music by Gipsy Kings, Mano Negro
Cinematography by Vittorio Storaro
Film Editing by Julia Juaniz
Production Design by Juan Botella
Costume Design by José María De Cossio

### 34. *Bulworth* (1998)

Senator Jay Billington Bulworth has become completely disenchanted with politics. He is fed up with all of the lying, cheating and money-grubbing,

so he takes out a contract on his own life. Before he goes out, however, he vows that he is going to defile his reputation by telling the truth. Then he falls in love with a black woman.

Directed by Warren Beatty
Written by Warren Beatty (story & screenplay)
Jeremy Pikser (screenplay)

CAST
Kimberly Deauna Adams – Denisha
Vinny Argiro – Debate Director
Sean Astin – Gary
Kirk Baltz – Debate Producer
Ernie Banks – Leroy
Amiri Baraka – Rastaman
Christine Baranski – Constance Bulworth
Adilah Barnes – Mrs. Brown
Warren Beatty – Senator Jay Billington Bulworth
Graham Beckel – Man with Dark Glasses
Halle Berry – Nina
Brandon N. Bowlin – Bouncer #2
Mongo Brownlee – Henchman #3
Thomas Jefferson Byrd – Uncle Rafeeq
J. Kenneth Campbell – Anthony
Scott Michael Campbell – Head Valet
Jann Carl – Herself
Kerry Catanese – Video Reporter #4
Don Cheadle – L.D.
Dave Allen Clark – Himself
Terry Cooley – Henchman #2
Kevin Cooney – Rev. Wilberforce
Christopher Curry – Journalist
Stanley DeSantis – Manny Liebowitz
Michael Clarke Duncan – Bouncer
Nora Dunn – Missy Berliner
Jerry Dunphy – Himself
Dartanyan Edmonds – Man with Blunt
Edward J. Etherson – Mr. Sasser
V.J. Foster – Photographer
Leon Curtis Frierson – Osgood
George Furth – Older Man
Xiomara Cuevas Galindo – Video Reporter #2
Robin Gammell – Geoffrey
Life Garland – Darnell's Bud
Jackie Gayle – Macavoy

Jim Haynie – Bill Stone
Randee Heller – Mrs. Tannenbaum
Barry Shabaka Henley – Man at Frankie's
James Hill – Journalist
Kene Holliday – Man in Church #1
Brian Hooks – Marcus Garvey
Terry Hoyos – Reporter #3
Myra J. – Woman in Church #1
Mario Jackson (II) – Snag
Ariyan A. Johnson – Tanya
Jedda Jones – Woman in Church #2
Michael Kaufman – Reporter #1
James Keane – American Politics Director
Tom Kelly – Reporter #5
Larry King – Himself
Deborah Lacey – Reporter #2
Mimi Lieber – Mrs. Liebowitz
Elizabeth Lindsey – American Politics Host
Joshua Malina – Bill Feldman
Larry Mark – Bouncer #3
Helen Martin – Momma Doll
Armelia McQueen – Ruthie
Laurie Metcalf – Mimi
Michael Milhoan – Cop #1
Jamal Mixon – Little Gangsta
Jerod Mixon – Little Gangsta
Debra Monk – Helen
Deborah Moore – Reporter
Michele Morgan – Cheryl
Patrick Morgan – Studio Employee
Juli Mortz – Larry King's Assistant
Scott Mosenson – Video Cameraman
Paul Motley – Janitor in Senate Office
Chris Mulkey – Cop #2
Lou Myers – Uncle Tyrone
Shawna Nagler – Technical Director
Jonathan Roger Neal – Little Gangsta
Ron Ostrow – Staff Member
Norman Parker – Irwin Tannenbaum
James Pickens Jr. – Uncle David
Wendell Pierce – Fred
Oliver Platt – Dennis Murphy
Kenneth Randle – Little Gangsta
Tony Thomas Randle – Little Gangsta
Arthur Reggie III – Little Gangsta
Adrian Ricard – Aunt Alice

Ava Rivera – Video Reporter #3
Richard C. Sarafian – Vinnie (as Richard Sarafian)
Robert Scheer – Journalist
Sam Shamshak – Fundraiser Guest
Sarah Silverman – Second American Politics Assistant
Brooke Skulski – Reporter
Bee-Be Smith – Aunt Harriet
Paul Sorvino – Graham Crockett
Roberto Soto – Reporter
Florence Stanley – Dobish
Quinn Sullivan – Fundraiser Server
JoAnn D. Thomas – Rapper
Robin Thomas – Reporter in Hallway
Sheryl Underwood – Woman in Frankie's
Gary H. Walton – Bouncer #4
Jack Warden – Eddie Davers
Andrew Warne – Video Reporter
Isaiah Washington – Darnell
Lee Weaver – Man in Church #2
Kenn Whitaker – Henchman #1
Jermaine Williams – Paul Robeson
John Witherspoon – Reverend Morris
Sumiko Telljohn – Lady at Banquet
William Baldwin – Constance Bulworth's Lover (uncredited)
George Hamilton – Himself (uncredited)
Paul Mazursky – (uncredited)
John McLaughlin – TV commentator (voice) (uncredited)
Thom Tierney – Churchgoer (uncredited)

Produced by Warren Beatty, Pieter Jan Brugge, Frank Capra, Lauren Shuler Donner,  Victoria Thomas
Original music by Ennio Morricone
Non-original music by John Philip Sousa
Cinematography by Vittorio Storaro
Film Editing by Robert C. Jones, Billy Weber
Casting Jeanne McCarthy, Victoria Thomas
Production Design by Dean Tavoularis
Art Direction William F. O'Brien
Set Decoration Rick Simpson
Costume Design by Milena Canonero

## 35. *Tango* (1998)

A reflexive film if there ever was one. It's a film about fictional director Mario Suarez's quest to make the ultimate tango film. It may be based in autobiographical fact, or maybe not. Set in Buenos Aires, Argentina, it deals in retrospect with Argentina's dark years of political suppression and "disappearances." The fictional director Mario attempts to construct a film that will allow his dancers and musicians creative freedom and simultaneously satisfy the tango-mad Argentine audience. Mario falls in love with a beautiful and talented young dancer named Elena, who is the mistress of the ominous Angelo Larroca, a backer of his film. Mario's creative vision is questioned and his life gets quite complex.

Directed by Carlos Saura
Written by Carlos Saura

CAST
Miguel Ángel Solá – Mario Suarez
Cecilia Narova – Laura Fuentes
Mía Maestro – Elena Flores
Juan Carlos Copes – Carlos Nebbia
Carlos Rivarola – Ernesto Landi
Sandra Ballesteros – María Elman
Oscar Cardozo Ocampo – Daniel Stein
Enrique Pinti – Sergio Lieman
Julio Bocca – Julio Bocca
Juan Luis Galiardo – Angelo Larroca
Martin Seefeld – Andrés Castro
Ricardo Díaz Mourelle – Waldo Norman
Antonio Soares Junior – Bodyguard #1
Ariel Casas – Antonio
Carlos Thiel – Dr.Ramírez
Nora Zinsky – Woman Investor #1
Fernando Llosa – Man Investor #1
Johana Copes – Dance Teacher
Mabel Pessen – Woman Investor #2
Julio Marticorena – Man Investor #2
Viviana Vigil – Singer
Héctor Pilatti – Singer
Roxana Fontan – Young Female Singer
Cutuli – Master of Ceremonies
Néstor Marconi – Bandoneón Player #1

Adolfo Gómez – Bandoneón Player #2
Juanjo Domínguez – Guitar Player
Norberto Ramos – Pianist
Dante Montero – Bodyguard #2
Ángela Ciccone – Palmira Fuentes
Fernando Monetti – Homero Fuentes
Ángel Coria – Assistant Choreographer
Sofía Codrovich – Ana Segovia
Elvira Onetto – School Teacher

Produced by Alejandro Bellaba, José María Calleja, Juan Carlos Codazzi, Carlos Mentasti, Luis A. Scalella
Original music by Lalo Schifrin
Cinematography by Vittorio Storaro
Film Editing by Julia Juaniz
Production Design by Emilio Basaldua
Costume Design by Milena Canonero, Beatriz De Benedetto

## 36. *Goya en Burde Fos* (1999)
    … aka *Goya* (2000) (Italy)
    … aka *Goya a Bordeaux* (2000) (Italy: promotional title)
    … aka *Goya in Bordeaux* (1999)

A dreamlike masterpiece of autobiography, *Goya in Bordeaux* is a journey through the mind of the master painter in his later years as he remembers his life. The production team of Carlos Saura, Vittorio Storaro and art director Pierre-Louis Thevenet have fabricated a theatrical phantasmagoria incorporating a moving camera, everchanging lighting and Goya's art. Many masterworks of the great painter are visually incorporated into the narrative using backlit screens with printed imagery. The narrative of Goya's life is insightfully and movingly told within the context of his art.

Directed by Carlos Saura
Written by Carlos Saura

CAST
Francisco Rabal – Goya
José Coronado – Goya as a Young Man

Daphne Fernández – Rosario
Maribel Verdú – Duchess of Alba
Eulalia Ramón – Leocadia
Joaquín Climent – Moratin
Cristina Espinosa – Pepita Tudo
José María Pou – Godoy
Saturnino García – Priest/San Antonio
Carlos Hipólito – Juan Valdes

Produced by Andrés Vicente Gómez, Fulvio Lucisano, Carmen Martínez
Original music by Roque Baños
Cinematography by Vittorio Storaro
Film Editing by Julia Juaniz
Production Design by Pierre-Louis Thévenet
Art Direction Pierre-Louis Thévenet
Costume Design by Pedro Moreno
Second Unit Director or Assistant Director
Carlos Saura Medrano….assistant director
Sound Department Carlos Faruelo
Special Effects Fabrizio Storaro

## 37. *Mirka* (1999)

Directed by Rachid Benhadj

CAST
Karim Benhadj – Mirka
Barbara Bobulová – Elena
Gérard Depardieu – Strix
Michele Melega – Tico Franco Nero
Vanessa Redgrave – Kalsan
Sergio Rubini – Helmut

Cinematography by Vittorio Storaro
Production Design by Gianni Quaranta
Special Effects Fabrizio Storaro (Vittorio's son) – digital effects supervisor
Other crew Stefano Ballirano – senior digital artist

## 38. *Picking Up the Pieces* (2000)
Tex, a kosher butcher, discovers his faithless wife in the act of infidelity and kills her in a fit of rage.

He dismembers her body to conceal his crime and buries it in the desert. Mysteriously, a hand surfaces, which a blind woman stumbles upon, only to find her sight restored. The hand is suddenly assumed to be the "hand of the Virgin." A priest and the mayor in town drum up a free-for-all of TV crews, miracle-seekers and local prostitutes ,who are all fixated on the hand. Tex frantically attempts to recover the hand before the local police can use it as evidence against him.

Directed by Alfonso Arau
Written by Bill Wilson

CAST
Woody Allen – Tex Cowley
David Schwimmer – Leo Jerome
Maria Grazia Cucinotta – Desi
Cheech Marin – Mayor Machado
Kiefer Sutherland – Bobo
Lou Diamond Phillips – Officer Alfonso
Alfonso Arau – Doctor Amado
Danny De La Paz – Lalo
Andy Dick – Father Buñuel
Fran Drescher – Sister Frida
Joseph Gordon-Levitt – Flaco
Elliott Gould – Father LaCage
Eddie Griffin – Sediento
Mía Maestro
Lupe Ontiveros – Constancia
Pepe Serna – Florencio
Sharon Stone – Candy
Angélica Aragón – Dolores
Jorge Cervera Jr.
O'Neal Compton
Richard Edson – Edsel
Jackie Guerra – Meche
Jon Huertas – Paulo
Kathy Kinney
Tony Plana – Usher
Cecilia Tijerina – Leticia
Enrique Castillo – Grasiento
Marcus Demian – Ricardo
Hector Elizondo
Dyana Ortelli – Gaga

Richard C. Sarafian (as Richard Sarafian)
Lily Tomlin

Produced by Alfonso Arau, Mimi Polk Gitlin, Donald Kushner, Peter Locke, Paul Sandberg, Rony Yacov
Original music by Ruy Folguera
Cinematography by Vittorio Storaro
Film Editing by Michael R. Miller
Casting Mary Gail Artz, Barbara Cohen
Production Design by Denise Pizzini
Costume Design by Marilyn Matthews

## 39. *Traviata, La* (2000) (TV)

Directed by Giuseppe Patroni-Griffi (as Giuseppe Patroni Griffi)
Written by Francesco Maria Piave (libretto)

CAST
Eteri Gvazava – Violetta Valery
José Cura – Alfredo Germont
Rolando Panerai – Giorgio Germont
Raphäelle Farman – Flora Bervoix
Nicolas Rivenq – Barone Douphol
Alain Gabriel – Gastone
Magali Ceger – Annina
Giorgio Gatti – Marchese d'Obigny
Víctor García Sierra – Dotor Grenvil
Antonio Márquez – Toreador

Produced by Andrea Andermann, Rada Rassimov
Music by Giuseppe Verdi
Cinematography by Vittorio Storaro
Art Direction Aldo Terlizzi
Set Decoration Christian Siret

## 40. *Dune* (2000) (TV Miniseries)

Directed by John Harrison
Written by Frank Herbert (novel),
John Harrison (teleplay)

CAST
Laura Burton – Alia
Julie Cox – Princess Irulan
Giancarlo Giannini – Emperor Shaddam IV
William Hurt – Duke Leto Atreides
Matt Keeslar – Feyd
Barbora Kodetova – Chani Pavel Kríz
Philip Lenkowsky – Guild Agent
Ian McNeice – Baron Vladimir Harkonnen
P.H. Moriarty – Gurney Halleck
Alec Newman – Paul Atreides
Uwe Ochsenknecht – Stilgar
Saskia Reeves – Jessica

Produced by Mitchell Galin, David R. Kappes, Richard P. Rubinstein
Cinematography by Vittorio Storaro
Film Editing by Harry B. Miller III
Casting Molly Lopata
Production Design by Miljen Kreka Kljakovic
Costume Design by Theodor Pistek
Special Effects Ernest D. Farino – visual effects supervisor

## FILMOGRAPHY
### (Actor)

1. ***Bertolucci secondo il cinema*** (1975)
… aka *Cinema According to Bertolucci, The* (1975)
… aka *Making of '1900', The* (1975)

2. ***Apocalypse Now*** (1979) (uncredited)
… TV Photographer

3. ***Visions of Light*** (1992) … Interviewee
… aka *Visions of Light: The Art of Cinematography* (1992)

4. ***Különbözö helyek*** (1995) … Himself
… aka *Different Places* (1995)

5. ***Ljuset håller mig sällskap*** (2000) … Himself
… aka *Light Keeps Me Company* (2000) (Europe: English title)

## FILMOGRAPHY
### (Miscellaneous Crew)

1. ***Captain Eo*** (1986) (lighting and photographic consultant) (visual consultant)

2. ***Continental*** (1989) (acknowledgement)

3. ***Visions of Light*** (1992)
… aka *Visions of Light: The Art of Cinematography* (1992)

— Ray Zone

# INDEX